Cartoons and Comics

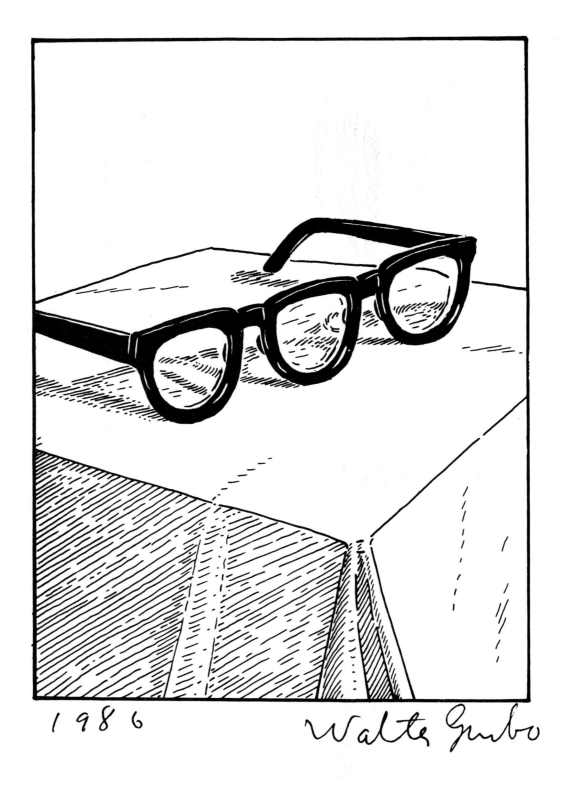

1986     Walter Gurbo

# Cartoons and Comics

# Ideas and Techniques

## Bob Sarnoff

Davis Publications, Inc.
Worcester, Massachusetts

*Printed in the United States of America*

*Library of Congress Catalog Card Number:*

*ISBN:* 0-87192-202-9

*Graphic Design:* Janis Capone

# Contents

# 1 Making Your Mark: Tools of the Cartooning Trade

Ever since time began we have sought ways to make a mark, a stroke—hopefully of genius—upon this world. With no art supply store at the rear of the cave, prehistoric people used sticks and stones and animal hairs for drawing implements. With no stationery store that carried bond typing paper, our forerunners used the walls, pressing pigment from berries and charcoal into animal fat, making the lines on the surface last for centuries.

Poor artists blame their tools. There is no recorded evidence that the cave artists complained about their sticks or fatty inks. Every artist/cartoonist should try a variety of pens and pencils and papers to find what accomplishes the best results.

## In This Material World

### Pencils

Did you ever wonder what the marking 3H means on a pencil? Pencils are graded according to hardness: 6H is the hardest, 5H, 4H, 3H, 2H, to H; then ranging from 1B to 6B, the softest. For most purposes, a soft pencil is advisable. If you keep it

sharpened, you can draw as fine a line as a hard pencil but with less pressure. This makes it easier to control and easier to erase. Some people like to use a mechanical pencil filling it with various grades of lead.

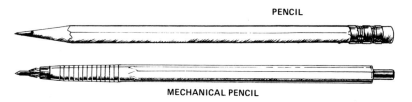

PENCIL

MECHANICAL PENCIL

## Erasers

Sometimes you can make a mistake or change your mind about a drawing. Even the cave artists had some trouble, but they either began again right over the drawing or moved to another wall. Luckily, you can use an eraser. Either a kneaded eraser or a gum eraser is fine. Try them both. If you sketch your cartoon lightly you should be able to remove any unwanted mark with either of these without too much effort and without a smudge or smear.

KNEADED ERASER

GUM ERASER

## Pens

Again, try a variety. Many professional cartoonists prefer fountain pens. They have a softer touch than "dip in pens," such as a crow quill pen and holder. The portability of a fountain pen is a plus making it a very useful sketching tool. Special fountain pens such as the Rapidograph control the flow of ink by means of a needle valve in a fine tube, the nib. Interchangeable nibs are available in several grades of fineness.

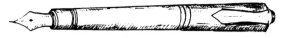

FOUNTAIN PEN

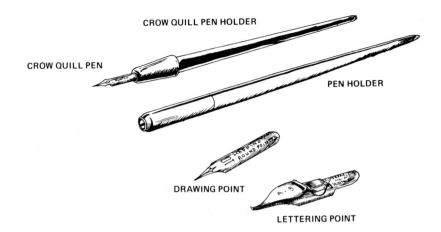

CROW QUILL PEN HOLDER

CROW QUILL PEN

PEN HOLDER

DRAWING POINT

LETTERING POINT

Rapidographs produce a line of even thickness. Crowquill penholders can take different points and are flexible, allowing for a variety of line. They require "dipping" into ink and can be messy until you get the feel of it.

Ball point pens have a tendency to make drawings look somewhat mechanical. They are inexpensive and useful for quick notes and scribbles. Felt tip pens are only slightly better; their points wear down to a fuzzy line. Hard nylon tip pens are very good because you can make a fine line when you press lightly and a good solid line when you apply some pressure. There are no mechanical parts as in a fountain pen or Rapidograph and no ink as in a crow quill set up. The mark is a strong black one.

RAPIDOGRAPH PEN

## Inks

INDIA INK

There is a variation among inks. Some waterproof India ink can clog a pen. Pelikan Fount India flows smoothly and does not leave a varnishy deposit on the pen. Ordinary fountain pen or writing inks are less opaque.

5

## Brush

Many cartoonists prefer to use a brush. A combination of brush and penwork leads to strong textures and effects. A brush produces a wonderful variety of line and, once mastered, results in good speed which professionals need to meet deadlines. Brushes come in nylon, camel or sable. They are numbered according to size. A #2 or #1 brush can duplicate nearly all the effects of the average pen nib—and more.

SABLE HAIR BRUSHES

## Surfaces

All purpose paper, newsprint, typewriter bond, Bristol board and illustration board are among the commonly used drawing surfaces. Try as many as possible. Ordinary inexpensive paper (brown wrapping paper or typing paper) is often as good as anything else when doodling or sketching. An inexpensive pad can be created by sandwiching a stack of bond typing paper between two pieces of equally sized cardboard. Use large paper clips to hold this all in place.

When the limitations of all purpose paper become evident, then it's time to move on to a better quality paper such as Bristol board. This paper has a smooth, hard, white surface designed for fine pen work. It has little tooth, which means it is not at all textured or rough and therefore allows a pen to run smoothly and easily. Erasing will not roughen up or ball up the paper, so ink will not spread or bleed. The ink will flow readily.

If you study professional work carefully and experiment with different tools and materials, you

T-SQUARE

will find what's right for you. Then practice, practice, practice. Investigate the possibilities at your local art supply store. Become inspired by the variety of materials that will enable you to create strokes of genius just like the cave artists.

## Other Suggested Tools

RULER

PUSHPINS

TRIANGLE

○ **T Square:** Helpful in drawing borders and keeping your straight lines parallel.
○ **Ruler:** Now you too can draw a straight line.
○ **Triangle:** Helpful in creating right angles and developing perspective.
○ **Drawing Table/Drafting Table:** You can use a table or desk or counter, but a drafting table is best because you can regulate the height and angle to suit your comfort while working.
○ **Pushpins:** Keep your paper in place while working on your table.
○ **Moveable Lamp:** Adjust the light to your liking.
○ **Lightbox:** Excellent for tracing/redrawing.

DRAFTING TABLE

MOVEABLE LAMP

LIGHTBOX (TRACING BOX)

# Character Development

Where to begin? When you think of all the comic strip characters that exist, it boggles the mind.... Superman, Batman, Charlie Brown, Dick Tracy, Spiderman, Wonder Woman, Dondi, Bugs Bunny, Mickey Mouse, Donald Duck, Woody Woodpecker, Dennis the Menace, Captain Marvel, The New Teen Titans, Tarzan...

Where did they come from? Okay, one of them came from Krypton, but how were they conceived? How were they invented? There are basically two ways any art form is created: perceptually and conceptually. Perceptual art is derived through the senses, particularly sight, which provide us with an awareness of our environment. Conceptual art comes from the imaginative process of original thought, original ideas, designs and images.

Let's see if we can rev up our ability to form new images; let's call upon our skills of combining previous experience with creative power. Here is a simple, direct and funfilling way:

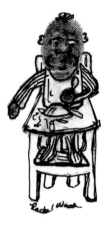

## Finger Print Character

We'll explore the art of simplicity in creating a cartoon character. Take your thumb or other finger and place it on a stamp pad or any source of ink. Then, make a fingerprint.

Look at the print and let your imagination run free. Have fun and jump right into drawing directly upon the print.

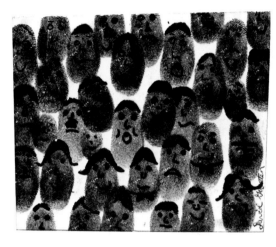

Establish a personality for your fingerprint character.

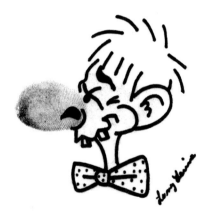

" THUMB THUMBNAIL SKETCHES "

## Finger Print Puns

What is a pun? Some think it is the lowest form of humor. Nevertheless, puns can make us smile, sometimes laugh. Puns are the humorous use of a word or words which are used in such a way as to play on two or more possible meanings. In other words, a pun is a play on words.

Think of how you can have fun with words related to fingerprints. Think of words such as "prints," "marks," etc. Use a dictionary. Use your powers of recall. Use your sense of humor: "Prints of Darkness."

THE QUIGMANS          by Buddy Hickerson

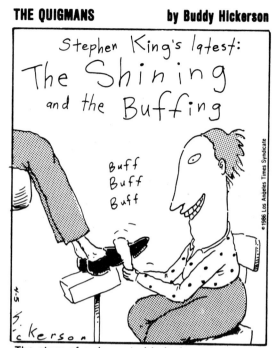

The story of a demented lad who gets tips for polishing off his victims.

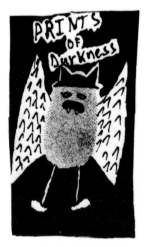

Think of homonyms—their spelling and their meanings.

Just let it go—have fun!

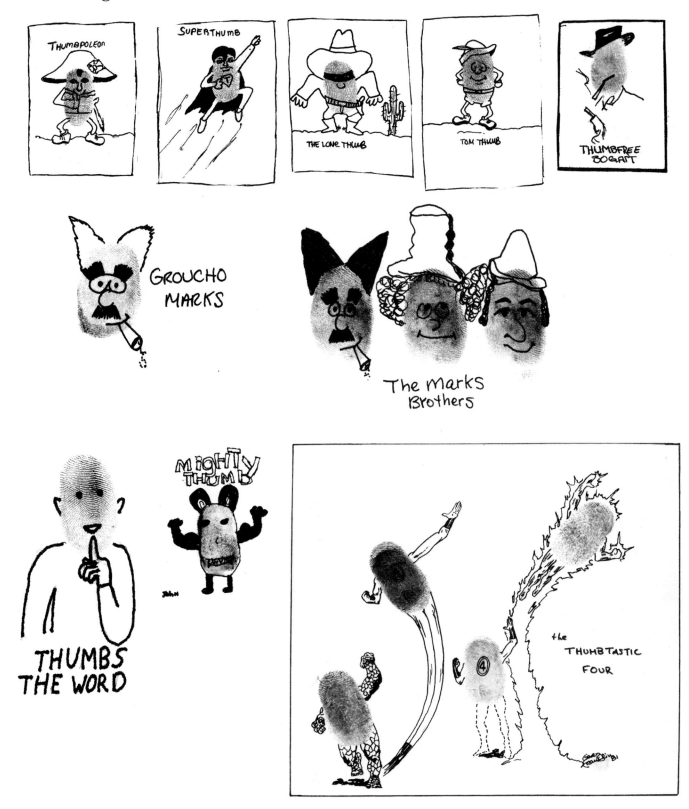

THUMBS LIB!

"Thumbleweed"

THORNTON

sPRINTer

"Thumbo"

THORNTON

Thumbrella

PINKY FLOYD

speak no evil
Rachel W.

see no evil

hear no evil

computer print out

THUMB TACK

KODAK PRINTS

A.C.

Tweedle Dee +
Tweedle Thumb!

THORNTON

Sometimes a little single frame cartoon is created.
(More about that later.)

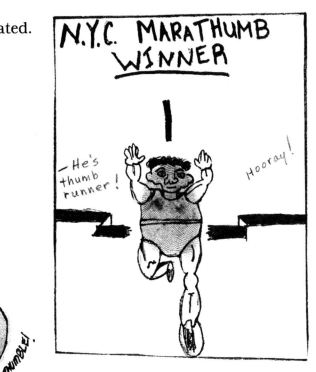

SUDDEN INPrint

THUMDAY MY PRINTS
WILL COME

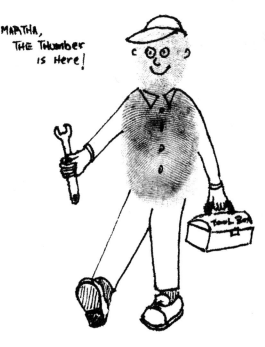

and finally...

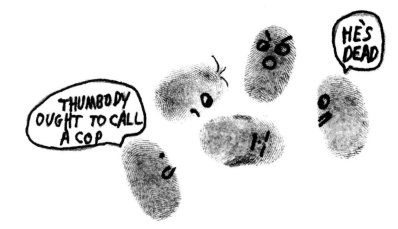

Don't let your character die...
Breathe life into him or her.
Have fun!
Make people smile...even laugh!
You have just created your first cartoons.
Congratulations!

# Creating a Simple Character Through Geometric Shapes

You can create your very own character by starting out with a circle and ending up with a large circle of friends.

○ Draw a circle, freehand or use a compass or round object.

○ Intersect it with horizontal and vertical guidelines right through the middle. Use these guidelines for the placement of features.

○ Add two eyes on guideline A. Simple black dots are O.K.

○ Add eyebrows above. You can create a highlight in the eye by leaving a bit of white. This has the effect of a sparkle in the eye and makes it come alive.

○ Now draw a nose where guideline A meets guideline B. A simple circle or line will do. Add a smiley mouth halfway between the nose and the chin.

○ Ears are positioned on guideline A. The top of an ear is *normally* on line with the eye, while the bottom of the ear is *normally* on line with the bottom of the nose. That's in real life! This is cartooning! Use this information as guides, as rules that can be bent a bit. We've all seen big ears or big noses, mouths that are closer to the nose than to the chin, etc. Add some hair—crew cut, curly or wavy—and you've drawn a cartoon character.

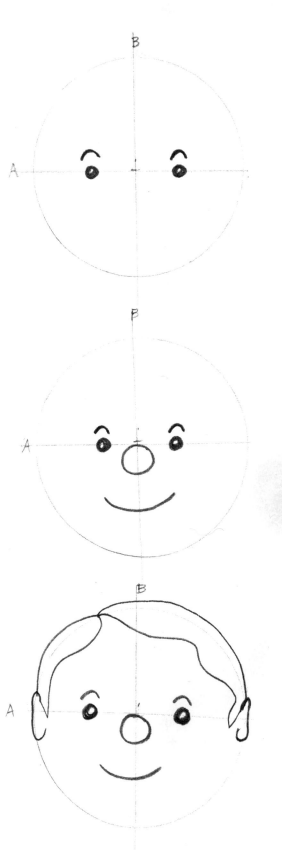

15

## Profiles

Sometimes you will want your character to be talking to someone or looking at something that is on the right or left. To draw them this way you will create the profile, the side view.

○ Draw a circle, free hand, compass or round object.
○ Intersect it with horizontal and vertical guidelines right through the middle as before.
○ Place an eye, a simple black dot with a highlight on guideline A all the way over to your left side.
○ Add an eyebrow over the eye.
○ Place the nose on guideline A on the left side of the circle.
○ Draw the mouth halfway between the nose and the chin on the left side of the circle.
○ Add hair.
○ Place the ear on guideline A relating it to the eye and nose as mentioned before in 3f.
○ You can tilt the guideline, enabling your character to look down or up.

Okay! Now that things are looking up, let's continue.......

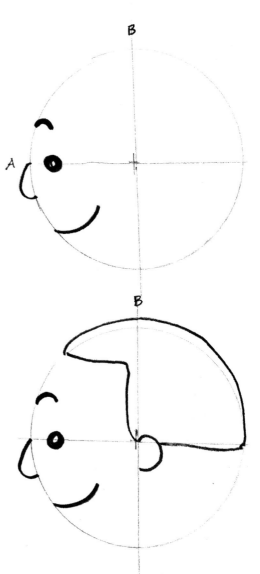

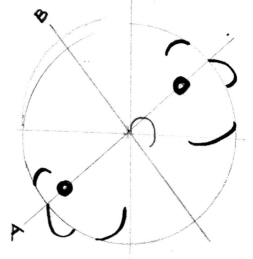

## Three-quarter Views

If you twist the axis of the circle so that your character is not looking straight or directly to the right or left, then you will be positioning him or her in a three-quarter view.

○ Imagine your circle as a ball with curved line B curving around it.
○ Add features as before, noting the location of the eyes in relationship to the nose. Since the head (the circle) is turned to the left, part of the face is not visible so the eyes appear closer together.
○ Part of the hair is now hidden as well, and so is part of the mouth.
○ Now you can combine the three-quarter view with the tilting guidelines.

Practice this way of creating characters from a circle. Expand your circle of friends by developing features that you find appealing, that your readers will find funny or cute or endearing.

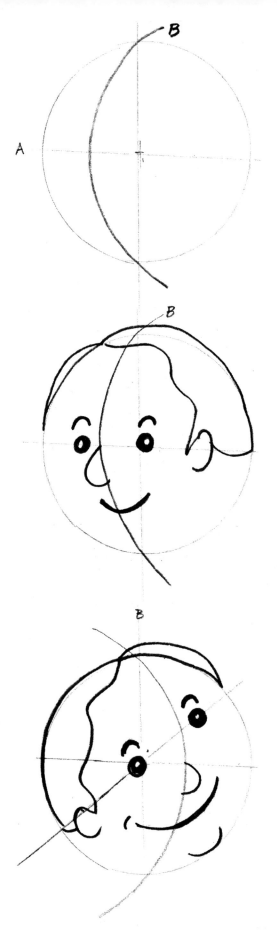

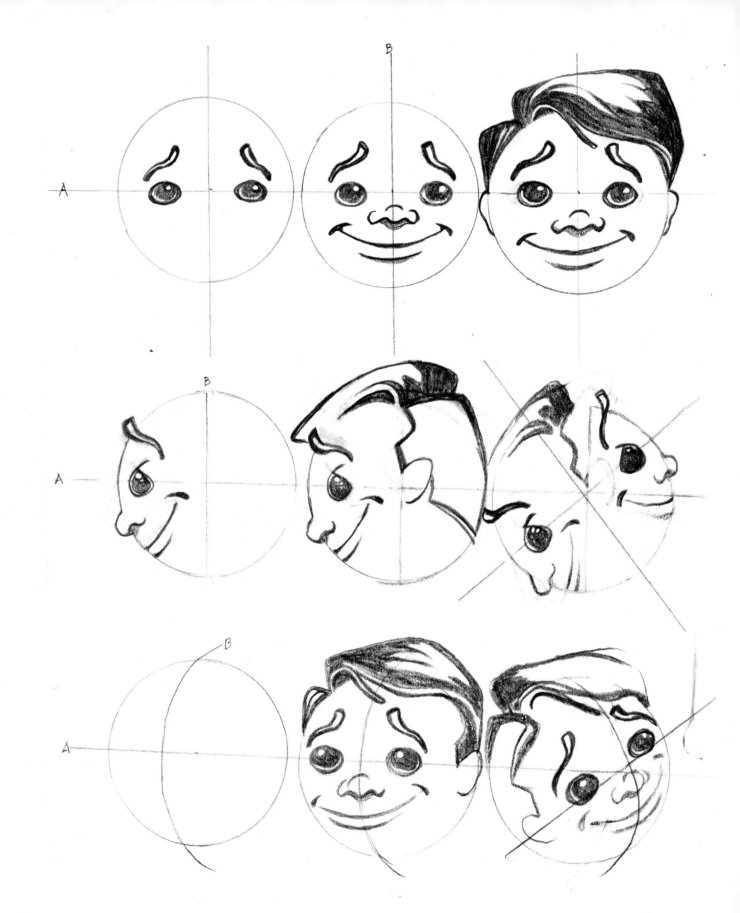

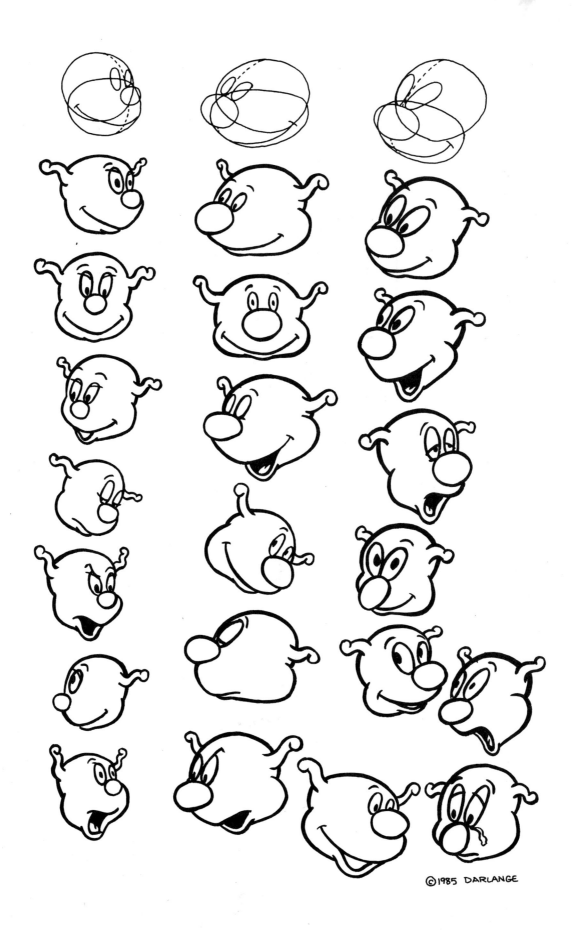

© 1985 DARLANGE

**Personality, Walk,
Personality, Talk. . . .**

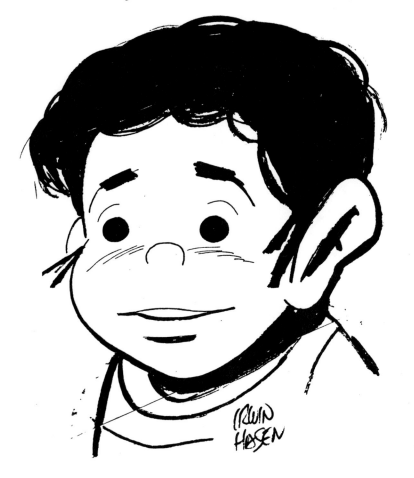

"Dondi" by Irwin Hasen

○ Starting with a free hand circle, begin to change the shape by making it more an oval or adding cheeks or developing a heart shaped look. Look all around you, in your class, on the train, bus, in the cafeteria. Faces come in all shapes and sizes.

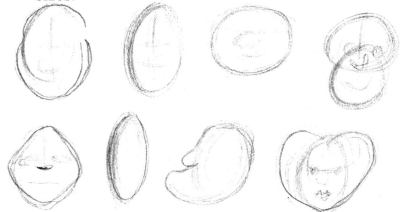

○ Now create your own features…the possibilities
are unlimited. The eyes are the soul of a person;
let's begin there. Keep looking and observing.

○ Eyebrows are helpful additions in creating per-
sonality. Look at your circle of friends.
○ Create your own versions, your own style.
Become identifiable!

○ Now on to noses.

○ Lips and mouths are next. Keep looking at your
friends, teachers, parents…Everybody!

○ Ears. What? Ears!

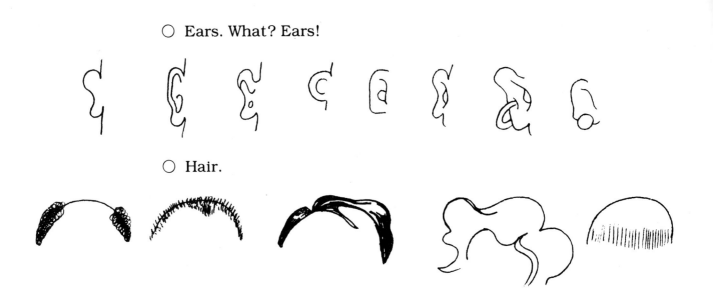

○ Hair.

Put everything together. Here Irwin Hasen, creator of "Dondi," tells us how he develops his cute and endearing young man:

"In the beginning the character (should be) someone you believe in—you are familiar with. Create a 'cast of characters' that the reader can identify with."

In his sketches he notes "eyeballs to depict anger, happy etc...[the soul of your character] 'His black eyes are a trademark'...Large ears and button nose...[to make him even more lovable]."

Dondi's circle of friends are sketched out by Mr. Hasen: Baldy with his full head of hair and Webster, the intellect with glasses, and let's not forget Queensie with his own personality.

This strip shows Dondi, Webster and Baldy in the midst of a conflict. (More about strips, scripts and conflicts later.)

22

IN THE BEGINNING THE CHARACTER
SOMEONE YOU BELIEVE IN — YOU
ARE FAMILIAR WITH — CREATE A
"CAST OF CHARACTERS" THE READER
IDENTIFIES WITH

EYEBROWS
TO DEPICT
ANGER,
HAPPY etc

LARGE EARS

BLACK EYES
A TRADEMARK

BUTTON NOSE

HIS FRIENDS — BALDY
SMART-ALECK
NATURALLY
LOTS OF
HAIR

WEBSTER
THE INTELLECT
GLASSES, HIS NAME
etc

GUBENSIE
A PET

WITH HIS
OWN
PERSONALITY

**DONDI**®
by Irwin Hasen

RELEASE WEEK OF SEPTEMBER 17, 1984

DID BALDY SAY HIS "FAMILY" ORDERED HIM TO HATE US?

THAT'S RIGHT, DONDI...

...BUT HE CAN'T BRING HIMSELF TO DO THAT SO INSTEAD, HE'S SAYING GOODBYE TO US FOREVER!

HEY, BALDY, WE'VE GOT TO TALK! WAIT UP!

# Expressions, Moods and Attitudes

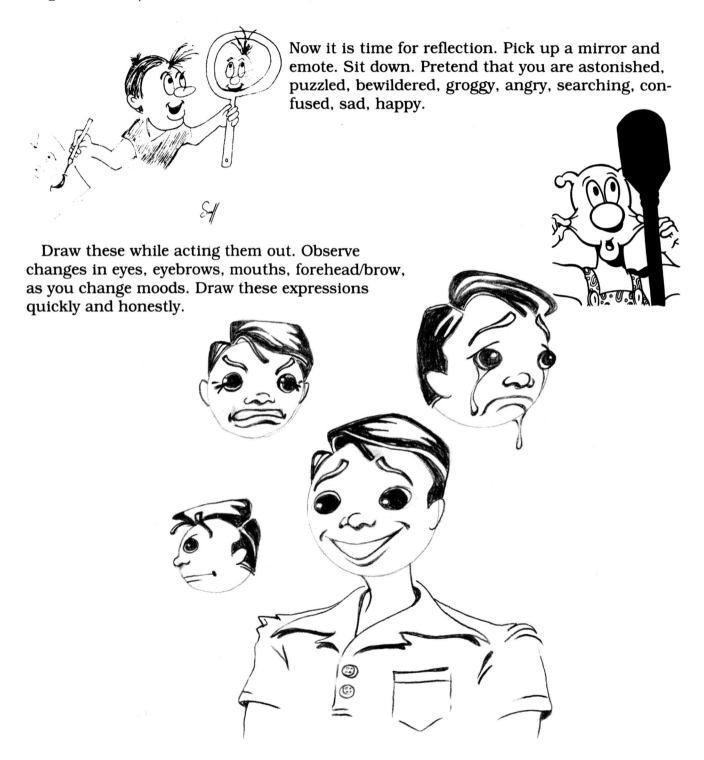

Now it is time for reflection. Pick up a mirror and emote. Sit down. Pretend that you are astonished, puzzled, bewildered, groggy, angry, searching, confused, sad, happy.

Draw these while acting them out. Observe changes in eyes, eyebrows, mouths, forehead/brow, as you change moods. Draw these expressions quickly and honestly.

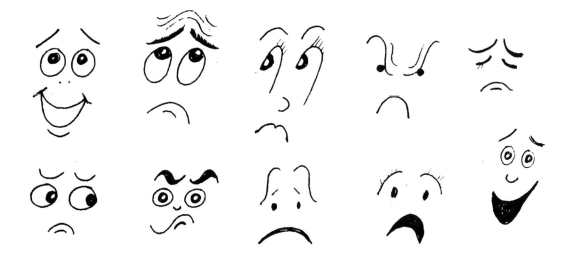

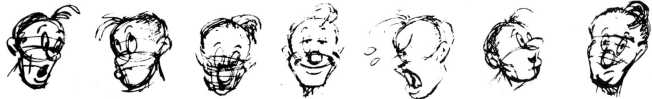

Gwenn Seuling

Here are some characters created by students:

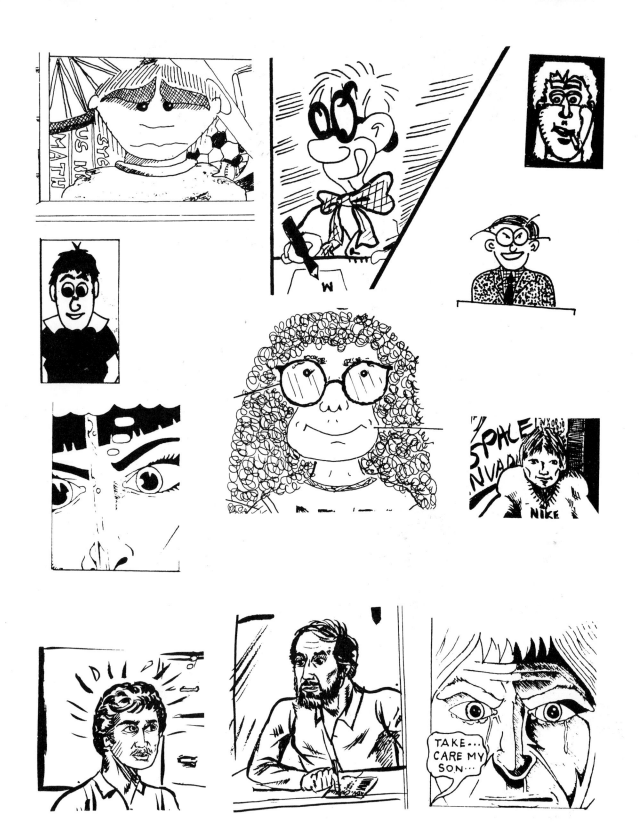

## Shorthand symbols to express mood.

Over the years, graphic representations of emotions, feelings and expressions have become part of the "Cartooning" vocabulary. These shorthand, simple, economic "pictures" are understood by everybody. They have become a universal language.

Picture your character in a cheerful mood, a tired mood, angry. Draw these moods as best you can using eyes, eyebrows, mouths to create expressions. Add shorthand pictorial representations. Here are some:

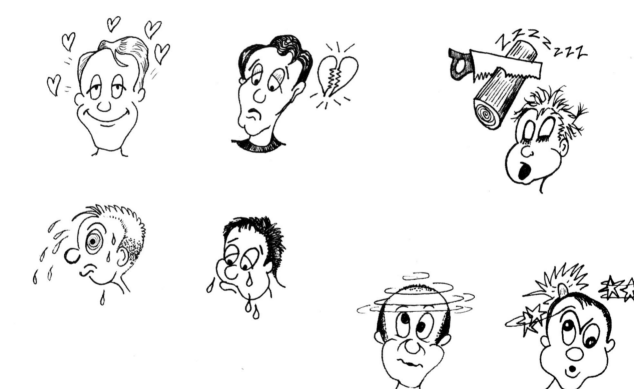

Think of others—jealous, smelly, rage, in pain. Look through comic books. Search for these symbols. Create your own; add to the universal language.

## Expressions of mood through body language

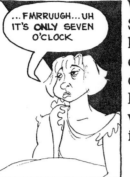

...FMRRUUGH...UH IT'S ONLY SEVEN O'CLOCK

We've all heard these statements: You're uptight, Stand tall, Be proud, Chin up, Weak-kneed, You look as if you're about to fall apart, etc. These are descriptions of the body when it is in a certain condition. These body positions reflect the inner self. Body language talks to whomever sees it. Observe what the body does when it is nervous, angry, anxious, afraid.

HMMNN.... I FEEL LIKE I FORGOT SOMETHING

HEY!

Gwenn Seuling

SORRY.

The beach, the train, the cafeteria all are great places to observe and capture people in various poses conveying various body languages—as Alan Funt of *Candid Camera* would say, "When they least expect it." Draw easily, quickly; let your hand translate what your eye sees. (More about this in the next chapter, "Contour Drawing.")

These quick sketches captured these people
when they least expected it.

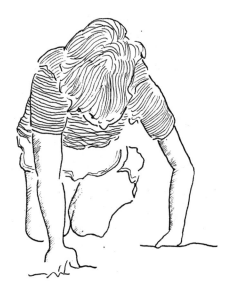

"THE KIBBUTZER"

Bob Sarnoff

Bob Sarnoff

Try to understand and capture the body's weight distribution, its tension, relaxation. All people are in a changing state of balanced tension and relaxation. Start out with a stick figure through which you draw a gravity line. This line falls between the feet, if the weight of the body rests equally on both feet. If all the weight is on one foot, the gravity line passes through that foot. This is good to know— just as it is good to know the proportions of the face. It is helpful in establishing the body's language. Observation is the best way.

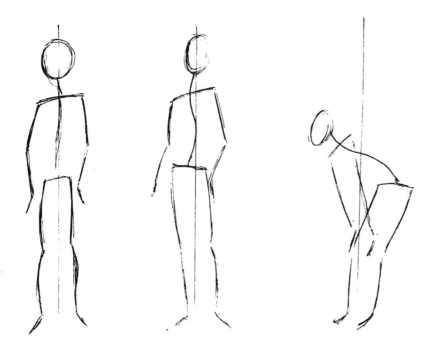

Gwenn Seuling of *Chic* Magazine, Paris, develops her characters' expressions of mood through body language by starting out with a bean-shaped torso, suggesting shoulders and hips and taking it from there.

It becomes clear where the expressions "uptight, Chin up, Weak-kneed," come from. You too can be *happy*! Become *determined* to draw cartoons the best you can! Soon you'll be so-o-o-o *suave*.

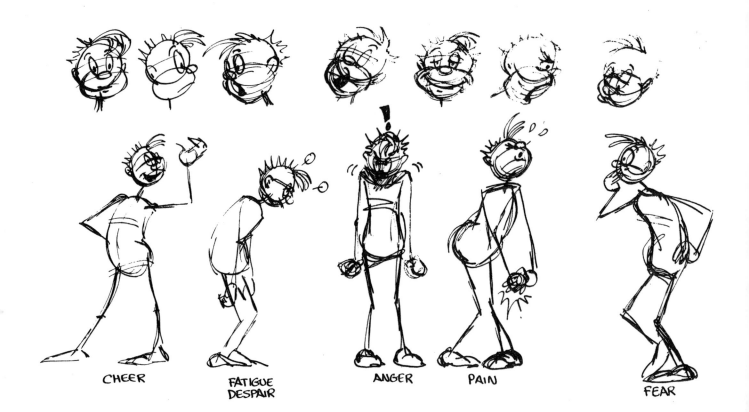

CHEER    FATIGUE DESPAIR    ANGER    PAIN    FEAR

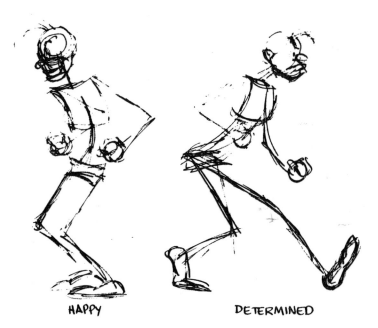
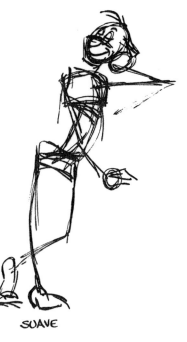

HAPPY    DETERMINED    SUAVE

Gwenn Seuling

**33**

## Making all the pieces fit

Place your character's face on a proper body. Do you want him or her to be short, tall, medium, fat, skinny? The average male is 8 heads high. The average female is $7\frac{1}{2}$ heads high.

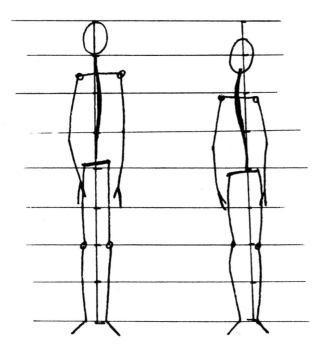

Remember this is "Cartooning." You are the creator. Do your own thing! Create your own characters! Have fun!

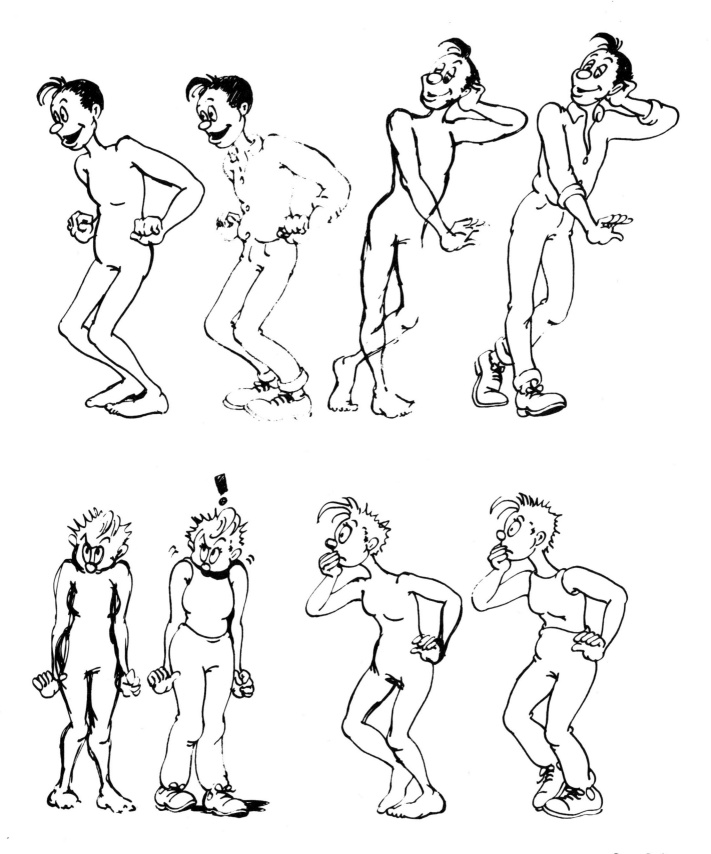

Gwenn Seuling

# 3 Contour Drawing

I've heard many students say, "I can't draw," or "I can't even draw a straight line."

This chapter deals with this imagined dilemma. First, sit down and relax. When you are comfortable, take out your pen and write your name on a piece of paper.

Good. Now, pass this to your neighbor, Sue Chambers, and have her pass hers to you. After a quick study, copy this signature to the best of your ability. Take your time.

When you are finished, take the same name and turn it upside down—yes, upside down. Now, copy it again as it appears to you (upside down). Take just as much time, or more, if need be.

Which way turned out better? Did you get better results the regular way or the second way? Why do you think it is better to turn the signature upside down when copying it?

When it is rightside up, you will be copying an "S," but there will be a strong tendency to copy that "S" in your own handwriting—the way you have done it for sixteen years or so. You won't really be copying it; you will be making your own "S."

When it is upside down, you are drawing—*drawing* lines and shapes, curves and designs, with no

realization that these are letters. Because of this drawing, you will be unaware that it is an "r" or an "m" or an "e" that you are rendering.

When you copy the signature rightside up, you have a pre-conceived notion of a letter, so that "S" will be a letter in your mind, and you will write it, not draw it. That is why the copying of a signature upside down results in a better reproduction of the configuration of shapes that happens to be a signature.

Believe it or not, this applies to anything or anyone you draw.

## Contour Drawing of Your Hand

Take your pen, with your drawing hand, and place it through the middle of a piece of scrap paper. This will prevent you from looking at your drawing surface.

Position your other hand in a comfortable but interesting position. Rest it on the table.

Now, here's the hard part. *Meditate!* Pretend that you are a little ant travelling along the outside of

your hand, sometimes entering the creases and crevices, but always returning to the outside.

*Do not begin to draw until you honestly and truly* feel *that you are that ant, that your pen, as an extension of you, is that ant.*

When you do believe this, slowly…slowly… smoothly…move across the terrain. *At no time should you peek at your paper. Do not look under the scrap paper shielding your view. Trust yourself. Do not worry about making any mistakes. There aren't any mistakes to make. This is an exercise.*

Look only at your hand while drawing.

How is this like copying your signature?

It's not preconceived; it's got personality. It's not stiff; it's unique.

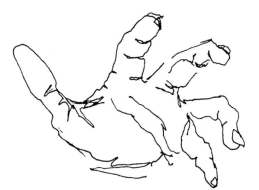

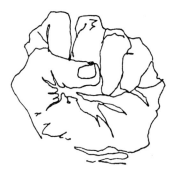

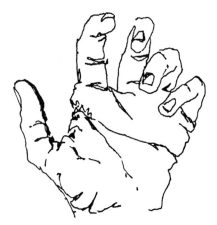

Rely solely upon your ability to follow the contours of your hand. The outside line is called the *exterior contour;* the inside creases are called *interior contours.* Follow all those contours.

That little ant should traverse over hill and dale, through canyons and rivers, taking that long journey over hairs and scars, over rings and wrinkles and birthmarks.

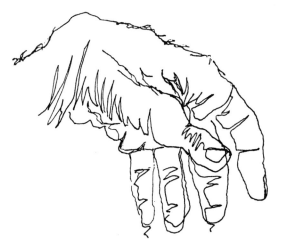

Blind contour drawing will teach you to trust yourself, to give you the confidence to draw anything. "What you see is what you get," a famous comedian, Flip Wilson, used to say. That's the truth when it comes to this type of drawing.

You haven't really *seen* anything until you've drawn it:

○ Draw a telephone dial complete with numbers and letters.
○ Draw the entrance to your house, including the front steps.
○ Draw the telephone while looking at it.
○ Draw the entrance to your house while looking at it.
○ Compare the two, noting similarities and differences.

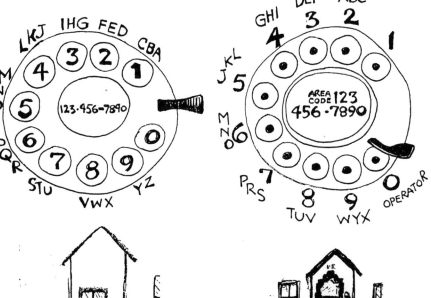

In case you still have doubts, have someone throw a ball as if he/she was pitching for his/her favorite major league baseball team. Make sure that the catcher gives a good target.

Note the pitcher's eyes. Are they looking at the ball? Where are they looking?

Have someone pretend to shoot a jump shot for his/her favorite basketball team. Note the person's eyes. Are they looking at the basketball or at the basket?

Why?

This is known as hand-eye coordination. What the eye sees is translated to the hand. There is no need to look at the baseball when pitching. Every pitcher looks at the catcher's mitt, the target. There is no need to look at the basketball when shooting. Every basketball player focuses attention on the basket.

When you draw, there is no need to look at the pen or the paper. You should concentrate on your subject! Trust yourself! What you see is what you get. The following blind contour drawings were created this way.

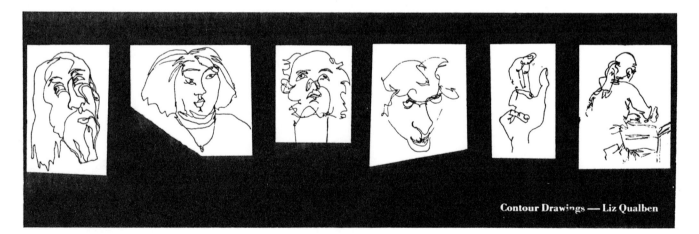

Contour Drawings — Liz Qualben

Set up a model. Have that person sit in a comfortable but interesting position. Think of this person as a signature, as a configuration of lines. Slowly but surely, follow the contours, interior as well as exterior. Try to complete the entire figure with one line, without lifting your pen. You may

**40**

wish to change your angle so as to create a variety of poses.

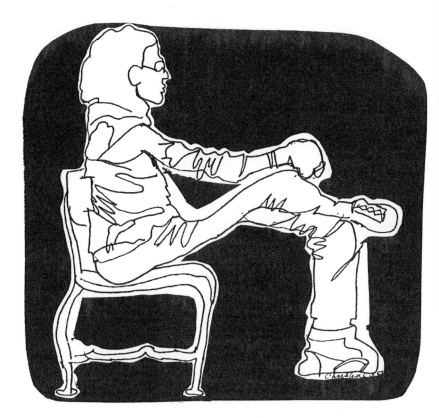

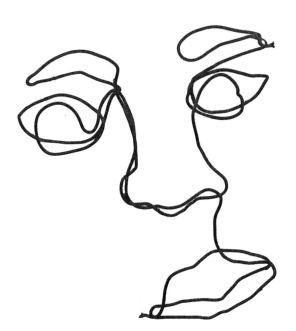

To prove that it is possible to create a drawing with one single line, take some wire, such as florist's wire or telephone wire, and make a "drawing" with it. Try a hand or a face before attempting a figure. Twist and turn it while looking at your target. Go from the exterior contour to the interior features and lines and then return to the exterior. Continue until you have completed the "drawing."

Instead of wire, try a string or thread "drawing." Dip the thread or string into a diluted solution of white glue and a little water. Spread the lines out as you investigate the contours of your model. Let the "drawing" dry.

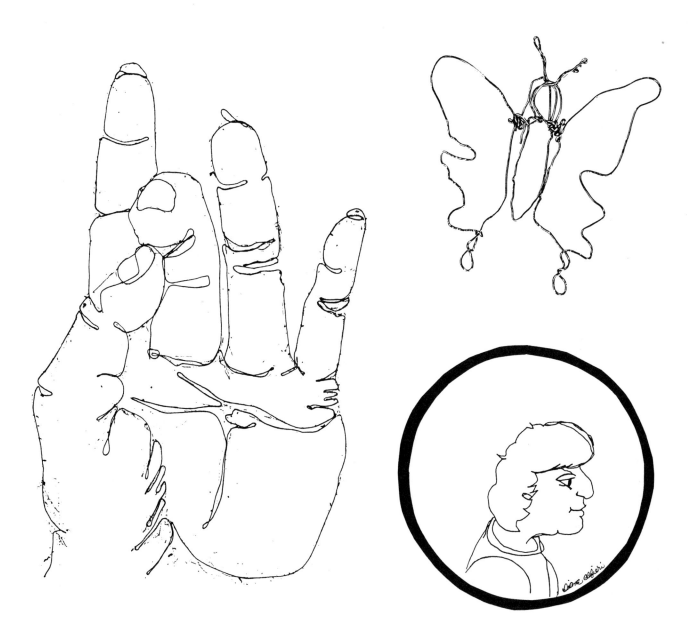

Now you can draw anything. All you have to do is sit down, concentrate, tune in to your target and become an ant. How, then, can you make a cartoon from these drawings? Well, you start out with these drawings and add speech balloons and thought balloons (more about those later) and, *voila*, you have created your first cartoon.

ALKI SONITIS

# Bringing to Life Inanimate Objects

As we have seen, cartoonists can bring to life finger prints and turn a line into a hand. They are magicians breathing life into such creatures as mice, ducks, woodpeckers, bears, pigs, rabbits, cats, dogs, even elephants!

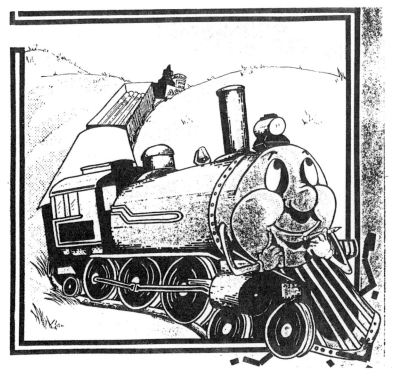

Gwenn Seuling.

To do this to broomsticks as Walt Disney did in *Fantasia's Sorcerer's Apprentice* (speaking of magic)—or as commercial artists do in their cartoon advertisements where everything from toilet paper, sandwiches, overnight packages, teeth, to bubbles and dough speak and sell products—is indeed quite an inventive feat.

It's our turn. Gather up your cartooning tools, your new found ability to draw anything and your sense of humor. Oh yes, don't forget your rich imagination!

Bring to life an inanimate object. Look around your room, your classroom, an office, focusing on objects that you see everyday: a book, a hairbrush, a zipper. Draw one of them with a sense of fun. Now look at your drawing and the object and see if you can attribute life-like qualities to this book or hairbrush or zipper. See if you can find a nose-like characteristic in your object, an eye, teeth, arms, legs.

Now breathe life, personality and character into your inanimate object. Give your new character a name that you write in such a way that it helps describe its purpose or essence. Show how your character does its stuff.

Here Gwenn Seuling draws an alarm clock who is definitely alive and "ticking." He/she wishes to make sure that every one else is up and at 'em as well.

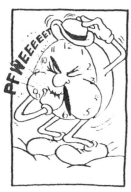

Gwenn Seuling.

Gwenn Seuling.

In this comic strip, created by one of my students, a devilish "Ralph the Rapidograph" annoyingly comes to life.... and death.

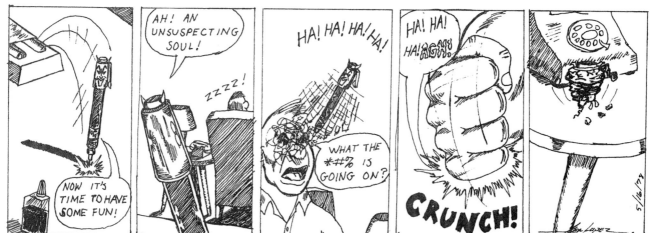

Walter Gurbo who illustrates for New York's *Village Voice* and *Playboy* goes a step further in his absurd, surreal renderings of what we normally think of as lifeless subjects.

See how far you can take this creative process, broadening the possibilities of communication, fun and humor. This is more a matter of invention, of letting your mind go free, of abstracting your thinking and allowing your pen to record these departures. "Train of thought leaving on Track 4."

Walter Gurbo

Walter Gurbo

# One Cell Cartoons

So far we have concentrated on tools, drawing, imagination, fun, absurdity. Let's not leave any of this behind as we proceed.

All of the work thus far has existed unto itself—on a page anywhere for its own purpose—just to be a drawing...and that is just fine, terrific.

Very often, however, a cartoonist must fill a certain space—in a newspaper or a magazine or a comic book. That space is called many things—sometimes '*#*%!!*!#X*!' when the artist can't think of anything to put inside. Usually it is called a panel or frame or cell.

When faced with this panel, professional cartoonists take different approaches. All however have the same problem of placement of their subject within this frame so as to create a balance and an interesting division of space. This is known as *composition*.

## Composition

This illustration is a classical example of the division of space. Here the consideration of balance and weight among the elements are so well

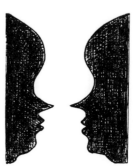

designed that the viewer cannot distinguish between what is the subject and what is the space surrounding or in between the subjects. When you concentrate on the dark and think of it as space, the middle white shape becomes a chalice or vase. When you concentrate on the dark and see the two profiles, the white shape becomes the space between. This is known as positive and negative space, positive being that drawn space that you can touch and negative being the air.

Take a piece of paper and fold it in half. Now cut out a small square so that you have a little window. Use this "viewfinder" and scan the room. Hold the window a few inches from your eye. Find a portion of the room or an object in the room and "zoom in" on it.

Draw that "zoomed-in" object in relationship to a frame that you have before you. Create several of these—zooming in via your viewfinder, selecting a particular subject and placing it in your given space, drawing the subject and the space around and in it, giving them all equal importance. Use black ink.

## Contrast

Continue to create these compositions, but this time alter what is black and what is white, that is, draw your zoomed-in subject again—this time switching black and white, reversing the negative space as well.

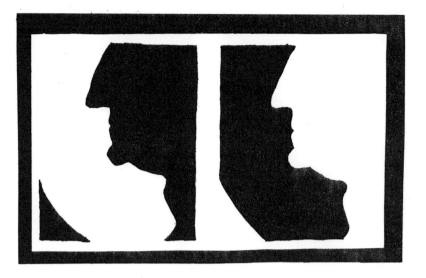

Not only will you be gaining experience in the division of space and the consideration of balance and weight among the elements, but you will be exercising your skills in establishing *contrast*—the creation of dark and light areas enabling the subject and background to stand out.

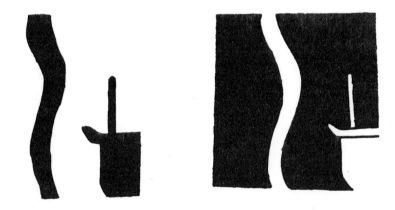

What you also will be mastering is an understanding of the need for variety in black and white areas. Continue these drawings.

Did you know that the illustration above is a plug and wire?...the illustration to the right is a closeup of a tennis racket?

In the examples below would
you believe that the middle panel is a bottle of
whiteout, not a hockey referee?...and that the right
panel is not a hockey stick and puck but an XCU,
an extreme closeup of a tape cassette?

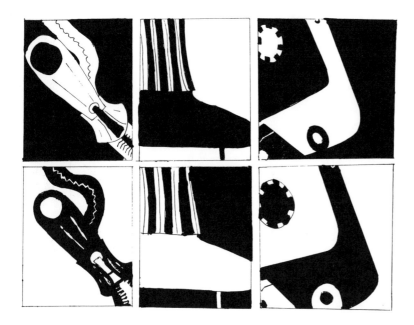

This student really investigated the possibilities
of a pistol, zooming in over and over again upon
different parts.

## Shading

In addition to the placement of your subject to create an interesting composition and the establishing of dark and light areas to create contrast, the cartoonist often wishes to vary tones within the work. This can be done in a few ways which we will explore now.

## Crosshatching

Take your pen and make lines in one direction very close together. Then cross those lines in another direction. This does not have to be done at right angles. Concentrate on your lines!

Practice by ruling two lines about one inch apart. Then divide these parallel lines into boxes. Make the first box black by blocking out all the white space while concentrating your lines very close together. Leave the last box white. Create different degrees of darkness in each box by altering the concentration of lines. Try to get from the black box to the white box in equal steps from very dark gray to light gray. This is known as a *gradation scale* and is an excellent way to practice this skill of crosshatching. Crosshatching is used to create textures, shading and varieties of light and dark areas.

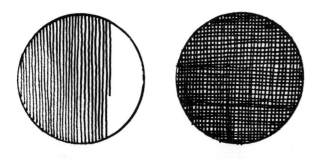

## Stippling

To create even greater variety in the look of your work's gray areas, textures, shadows, etc., you can stipple. Instead of concentrating your lines, concentrate your dots. The closer they are together the darker your area will be. Dots good!

Take a magnifying glass and look at a newspaper photograph. What do you see? Dots. Good! The dark areas have the dots concentrated close together while the light areas are further apart.

You can combine crosshatching and stippling within the same drawing as this student did.

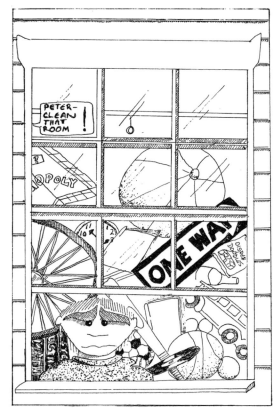

## Shading Film

Many professionals prefer to use shading film. It comes in sheets in a variety of tones and can look like concentrated lines or dots.

This lucky man's suit was worked with shading film by Buddy Hickerson.

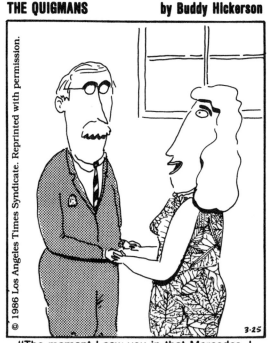

**THE QUIGMANS**          **by Buddy Hickerson**

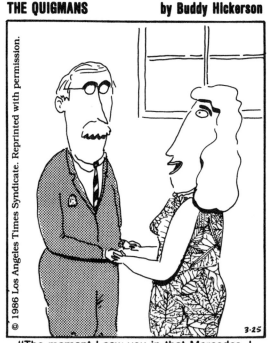

"The moment I saw you in that Mercedes, I knew you were the man I wanted to divorce."

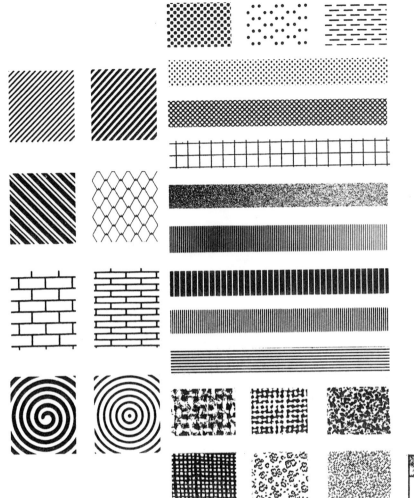

**How to use shading film:** First determine the area you wish to have a texture or a shadow or gray tone such as the flower pot in the illustration below. Place the sheet of shading film over the area and trace the shape. It's advisable to use a light-box, or if one is not available, hold your work up to a window.

Cut out the shape with an exacto knife or single edge razor. Do it carefully and precisely. The shading film has a sticky surface once you carefully peel off the protective paper. Place the cutout shape upon the object to be shaded and presto! There it is! The window shade and the sill were also worked with shading film in this Walter Gurbo cartoon.

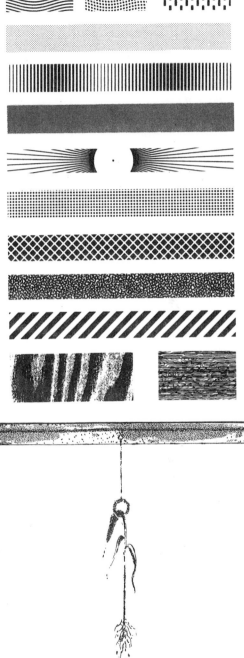

Walter Gurbo

# Keeping a Journal

As you can see from this cartoon, my students love to keep a diary or journal. Would you believe "like"?

Good cartoonists are more than just accomplished artists. They have to have something to say. They must be good observers of the human condition and then be able to write/interpret that experience visually and with some literal description. If you get into the habit now of writing and sketching what you see as having "cartoon potential" then you will be well on your way to success. Here is an example of a diligent student's journal:

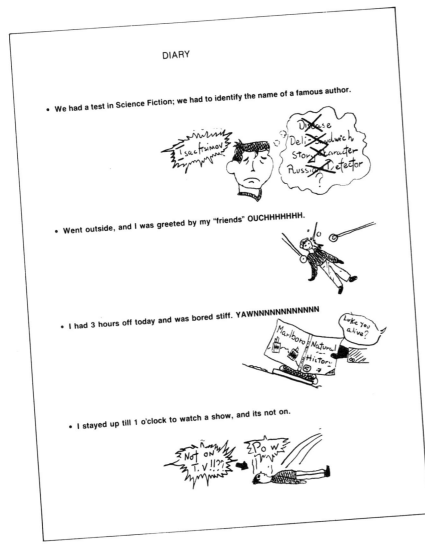

## MR. TWEEDY    by Ned Riddle

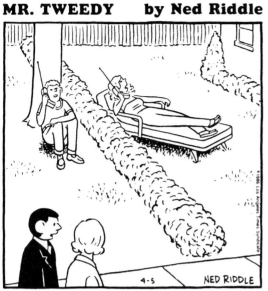

"Kids nowadays have to have a phone in their hands. Would you believe they're talking to each other?"

It doesn't have to be this formal. On-the-spot sketches and notes are fine as long as they are readable and referrable. But you must keep a diary! It is most important!

Thumbnail sketches of your journal entries lead up to your finished statement. In pencil start to build one of your entries into a more substantial sketch. Work on the composition. Work on the contrast. Establish some gray areas for variety.

Here Ned Riddle's "Mr. Tweedy" makes an observation about young people's infatuation with the telephone. This cartoon probably came from an entry he made somewhere on a pad, a matchbook cover, or napkin. Notice that the artist chose to have Mr. Tweedy's words appear at the bottom of the panel.

## Speech Balloons, Thought Balloons, Hot Air

When you want your character to speak and your reader to know that it is your character who is speaking, you can use a speech balloon. When your character is thinking you can show this by drawing a thought balloon.

You will want to make your copy (your words) readable. Therefore, your letters and the lines of words should be neat and legible. Use a ruler to measure the height of your letters. They should all be of equal height.

Most cartoonists use all capital letters. Use a ruler to measure the space between your lines of copy (just like a typewriter leaves space). Always leave space between your words. Practice, practice, practice making capital letters and spacing.

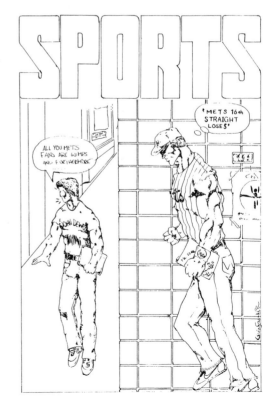

You can also use a tool for lettering called an Ames guide, which helps rule guidelines with proper spacing. You have to place the point of your pencil in the measured hole of the Ames guide and slide it back and forth against the edge of a T-square positioned on the paper. It takes some getting used to, but this will prove to be a valuable tool for lettering.

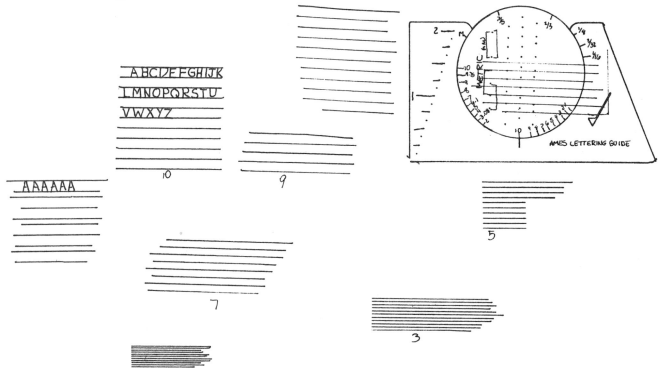

AMES LETTERING GUIDE

Computer printers are used by many professionals today to do their lettering. Familiarity with these is a good idea.

## Inking

Once you have your cartoon all sketched out exactly as you want it, it is ready for inking. Redraw the pencil work in ink. This will define the lines making them darker and ready for printing. You can use a nylon tip pen, Rapidograph pen, fountain pen (i.e., Pelikan), or India ink or crowquill pen. As mentioned in Chapter 1, find the

**Walter Gurbo**

**60**

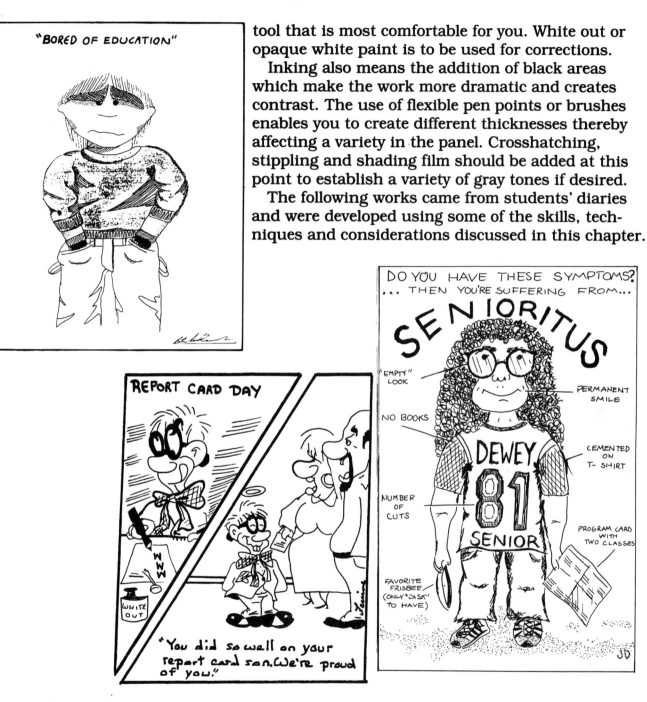

"BORED OF EDUCATION"

tool that is most comfortable for you. White out or opaque white paint is to be used for corrections.

Inking also means the addition of black areas which make the work more dramatic and creates contrast. The use of flexible pen points or brushes enables you to create different thicknesses thereby affecting a variety in the panel. Crosshatching, stippling and shading film should be added at this point to establish a variety of gray tones if desired.

The following works came from students' diaries and were developed using some of the skills, techniques and considerations discussed in this chapter.

Go for it! Choose an entry from your journal, one that you feel will communicate some universal truth or glimmer of recognition. Choose one that will put a smile on your readers' lips or even make them laugh out loud. Imagine that! Follow all these steps, step by step, and soon you will have created your very own single frame cartoon.

# One Cell Editorial Cartoons

6

Since George Washington's time, cartoonists have captured the political events of their day. If you were to research this art form from then until now, you would see a history of the conflicts that have confronted the United States reflecting national mood, incidents and personalities. These American satirists really thrive when issues and people of the time grab the nation's attention. They spare no one.

The editorial cartoonist in praise or criticism waves a powerful pen. His/her message is graphic and the impact is felt by millions of readers.

Ulysses S. Grant is purported to have said in 1868, "Two things elected me, the sword of Sheridan [one of America's most famous generals] and the pencil of Thomas Nast [one of America's most famous cartoonists]." On the other hand, President Nixon admitted in 1962 that he "had to erase the Herblock image." These are two examples of the pen being at least as mighty as the sword.

One cell editorial cartoons of the past also reveal much social history. Costumes of men and women, slave drivers, bowery boys, furniture, popular songs, colloquialisms and slang of the past are all evident. Slogans, banners, food, drink and tobacco and street scenes are all depicted.

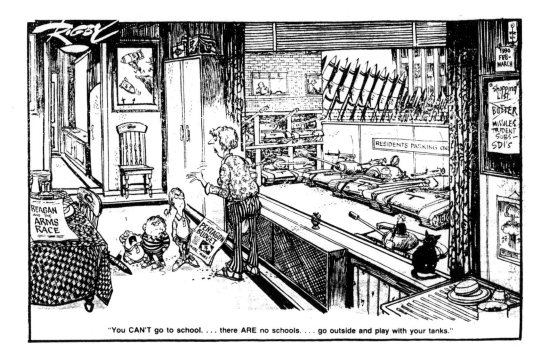

"You CAN'T go to school. . . . there ARE no schools. . . . go outside and play with your tanks."

The development of the symbolic figures such as Uncle Sam, the Republican Elephant, and the Democratic Donkey can likewise be traced by these cartoons.

As long as the United States has a free press, the pen and ink satirists of every important newspaper will be busy capturing the moment forever.

In this chapter we will concentrate on the creation of contemporary political/editorial cartoons. Here are some examples of my students that dealt with the issues and events of their day.

Fear of the nuclear holocaust prompted one student to take off from the famous Grant Wood painting *American Gothic* and add his own imagery: the mushroom cloud looming in the background and the gun in the man's hand.

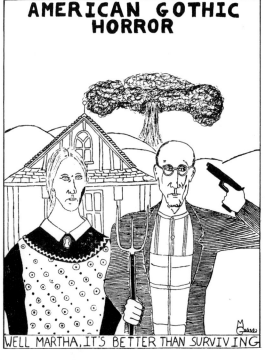

AMERICAN GOTHIC HORROR

WELL MARTHA, IT'S BETTER THAN SURVIVING

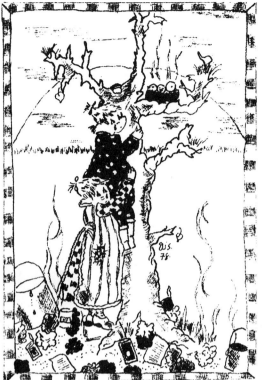

Another, upset by the environmental pollution, has her two little waifs—victims of the dirt and odors surrounding them—attempting to save three little baby birds, symbolizing nature's future generations.

The SST flights over New York in 1978, causing noise pollution and irritation, motivated this young artist to create a Godzilla-like representation of this monstrous airplane.

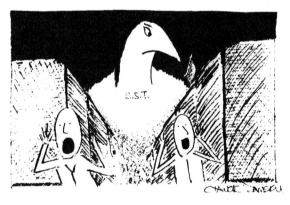

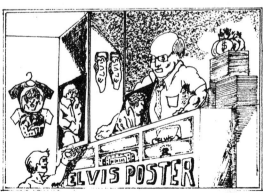

The commercialization of Elvis Presley's death is depicted by the storeowner and his stacks and bags of money as he sells still another of Elvis' paraphernalia.

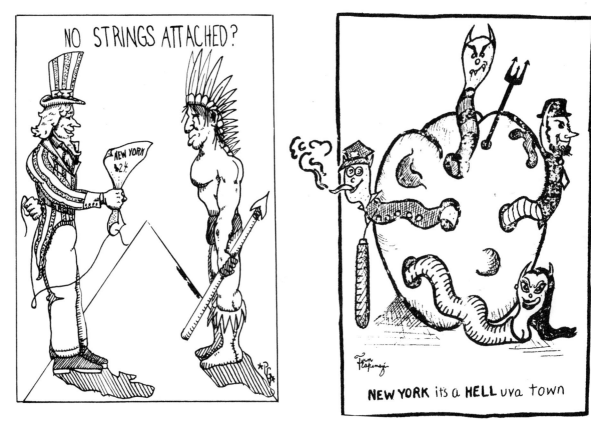

What is interesting about these two students' cartoons created in 1978 is their reflective forecast of the corruption to hit New York City's government in 1986. Paper, strings, Uncle Sam, the Indian, the rotten apple, worms and devils become rats and snakes and skeletons and bats in the

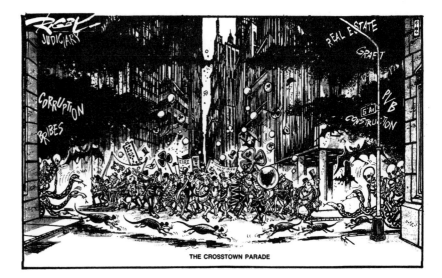

THE CROSSTOWN PARADE

hands of Rigby, the noted editorial cartoonist of the New York Daily News. Rigby deals with this same topic in the form of a "corruption" puzzle with words and names of those involved represented by pieces.

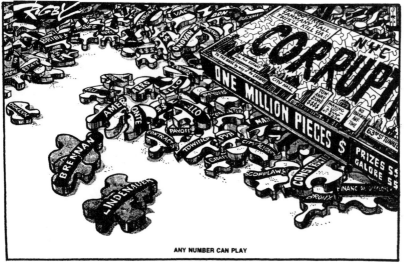

ANY NUMBER CAN PLAY

Rigby Daily News

Ever since Benjamin Franklin created the first American cartoon, the key to these graphic renderings has been their symbolic representation. How would you warn two countries to ready themselves for a battle? How would you urge Pennsylvania to prepare for defense in 1747? Franklin depicted Hercules on a cloud, leaning on a club, while in the foreground three horses struggle to draw a heavy wagon out of the mud. The wagoneer is praying to the gods to assist him. This alludes to the fable in which Hercules states, "Heaven helps only those who help themselves." This was the first printed attempt in America to *symbolize a political situation*. Was it anything like your idea?

Doves, olive wreaths, flames, purses of money, Pandora's Box, the American eagle, rats, crosses, the Republican Elephant, the Democratic Donkey, Uncle Sam, the dollar sign, the mushroom cloud, pieces of a puzzle are just some of the images that political cartoonists use to represent an event or issue. A Presidential race becomes a horserace, a defeat, a funeral, a contest between two political foes, a knock 'em out, drag 'em out pugilistic bout.

# Punch

"Well, that's it for today . . . let's see you try and sleep *that* off."

©1986 PUNCH PUBL. DIST. BY L.A. TIMES SYND.

It is time for you to create your own political cartoon. First you must become aware of the issues of the day.

Listen to the radio, read the newspaper, magazines and watch the news on television. Select an issue or event about which you have strong feelings.

Create thumbnail sketches of that topic determining what would best symbolically represent your viewpoint.

In this editorial cartoon by noted sports artist Bill Gallo of the New York Daily News, the Ugly Growing Drug Scene in Pro Sports is shown to be an enormous, gluttonous pig of a man whose stool is busted from his weight as he devours still another sports figure from football, boxing, hockey, basketball and baseball. These players sit on a tray nodding out and sniffing as the dealer portrayed by a villainous character serves them up. Bill Gallo chooses to add a message to all athletes as he pleads with his young readers as well not to end up on the platter.

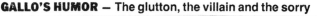

**GALLO'S HUMOR** — The glutton, the villain and the sorry                    **By Bill Gallo**

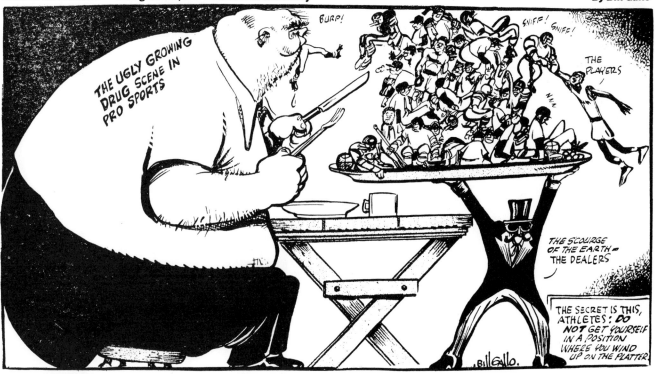

Bill Gallo Daily News

Develop your cartoon in ink remembering the other "C" words: composition, contrast, crosshatching. Of course, stippling, shading film, variety in inking, good clear, legible lettering and speech balloons if applicable should also be incorporated. Your work should be strong, bold and to the point—dramatic, effective...with a touch of wry wit!

Bill Gallo Daily News

This cartoon pretty well sums up 1985—everything from the Reagan-Gorbachev summit and the Mexican earthquakes to Dwight Gooden's fabulous year and Pete Rose's assault on Ty Cobb's record. "86" is a luncheonette expression meaning "We're all out of…". In this case, it refers to the year 1985 as it came to a close.

What would you post on the wall of this luncheonette for 1986? The Challenger disaster, Chernobyl's meltdown, the raid on Libya and Khadafi seem to be the major events. How else would you choose to sum up a year in cartoon form? Stay aware; keep abreast of world events, of local news. Perhaps your powerful pen one day will help someone become president!

# 1 One Cell Editorial Cartoons With Caricatures

Every president since George Washington has had his portrait rendered in oils for posterity. Every president has also had a cartoon drawing made of him. These were usually unsolicited and uncommissioned and tended to show the chief executive warts and all. These drawings are known as caricatures: the deliberately distorted picturing or imitating of a person by exaggerating features or mannerisms for satirical effect.

Many famous political cartoonists who incorporate caricatures in their work feel that this art form is not just exaggeration—the elongation of a nose or the accentuation of a five o'clock shadow—but an attempt to reveal the inner-self of a person through his or her outward features and expressions.

The more colorful the presidents, the more appealing they were as subjects for the satirists. Many became targets mainly because their appearance lent itself to caricature, i.e., Lincoln for his gauntness, beard, stovepipe hat, moles and dark brooding eyes; Franklin Roosevelt for his jutting jaw and confident grin; John F. Kennedy for his shock of hair and toothy smile; and Richard Nixon for his prickly jowls, ski slope nose and beady eyes.

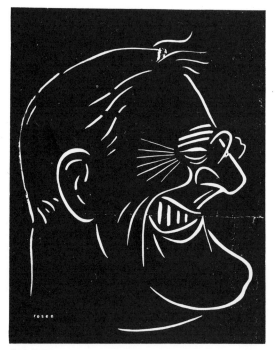

Jack Rosen

70

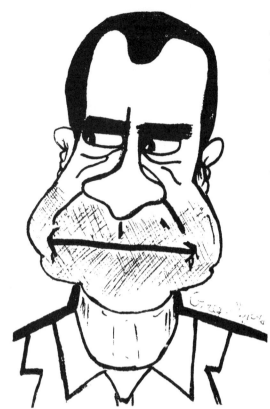

One of America's most famous cartoonists was Thomas Nast. During the 1860s, the Civil War and Abraham Lincoln helped focus political cartooning. The issues were summarized concisely, dramatically, effectively. Economy would replace crowded, complicated pieces. Nast swayed voters in every presidential election from Lincoln's in 1864 through Cleveland's in 1884. Imagine how different America might be if Mr. Nast didn't support Lincoln and Grant!

Almost every important daily newspaper soon had its cartoonist, and because they covered new issues as soon as they broke, the work tended to become more simple and direct.

In 1901, Theodore Roosevelt's exuberance, moustache, broad toothy smile complete with spaces and his thick lenses motivated the satirists of his day. Everything he said and did was recorded visually in a broad, graphic way.

World War I, the war to end all wars, stimulated cartoons just as the Civil War did. The world was being made safe for democracy. World War II and the following years recruited an army of new cartoonists: Bill Mauldin, Herblock, Paul Conrad, Pat Oliphant, Jules Feiffer, David Levine, Rigby.

In this chapter, we investigate just how these artists go about creating their caricatures and how you too can incorporate your rendition of a famous personality into your very own editorial cartoon.

## Exaggeration, Elongation and Diminution

Pablo Picasso studied the human anatomy and facial structure and at a very early age mastered the skills and techniques necessary to render a realistic drawing of these subjects. Then he was able to abstract and distort features and the relationships of these features.

In Chapter 2 we examined the face and how you can go about drawing it "correctly." Refresh your memory. Then, select five photographs of *one*

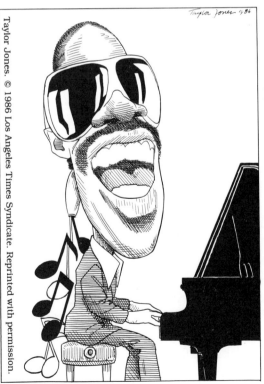

famous personality, someone that you really admire or detest. This attitude will motivate you to dig in and get involved with your political figure, celebrity or sports hero. Several angles are helpful in understanding this person's face. Bill Gallo's farewell to James Cagney is a great example of rendering from different positions.

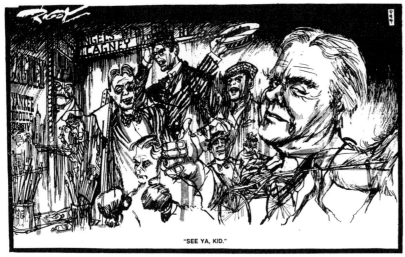

"SEE YA, KID."

Bill Gallo, Daily News

Using your skills and knowledge of proportions and relationship of features, draw your personality's face as best you can. Contour drawings are helpful so sketch a few of these as well.

Although you may think this is "cheating," make a tracing of this personality by using a light box or tracing paper. Still another way to achieve a good drawing of this face is to place carbon paper under the photograph and draw directly on the photograph with a ball point pen that has no ink. The impression will result in a fairly accurate rendition of that person.

Analyze the size of the features. Does he have a big nose? Are her lips the dominant feature? Are his eyes really small? Should her hair be emphasized? His moustache is ridiculous! Play with your drawings and exaggerate your observations. Keep doing this until you are satisfied that you have captured what you want.

Now determine the relationship of the features. Her eyes are really wide apart. His forehead is gigantic and his balding head makes it look even

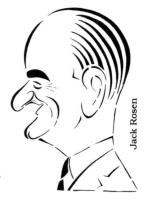

Jack Rosen

larger. All his features seem to be pushed down to the bottom of his face. His nose seems to touch his upper lip. She doesn't seem to have a chin.

Now is the fun part—and the hard part. Put all this together! If you have established that the hair is the dominant characteristic along with the many wrinkles, well, go to it. Elongate the nose; place the eyes close together; diminish the size of the mouth if you think it is unusually small. If someone has a toothy smile, then accentuate it.

"P.B.S. IS PROUD TO ANNOUNCE THE ACTING DEBUT OF PRESIDENT CARTER IN OUR NEW 13-WEEK MASTERPIECE THEATRE PRESENTATION..."

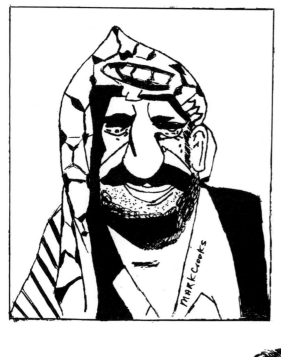

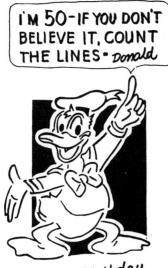

Happy Birthday
Jack Rosen

Jack Rosen creates his caricatures with a novel twist, by having the number of strokes in the drawing correspond to the subject's age. "It's a good thing President Reagan has that pompadour", he says. The first "age-i-cature" was sent in 1931 to George Bernard Shaw. Rosen also congratulated Donald Duck on his 50th birthday with an age-i-cature.

He started off by sketching his grade school teachers on the Lower East Side of New York. That's a good way to practice but make sure you pay attention in class.

BIRTHDAY CARTOON OF OUR PRESIDENT MADE IN 75 BRUSHSTROKES CORRESPONDING TO HIS 75 TH BIRTHDAY.
JACK ROSEN
2·6·'86

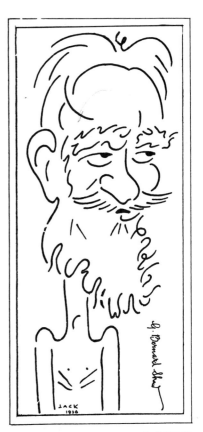

Jack Rosen

Continue to pull and push those salient features, their relationships, their size until you create the arrangement you feel says it all. If you can combine something political/topical/eventful about that person, then all the better. You are on your way to creating an editorial cartoon with a caricature.

Here Mayor Koch of New York, drawn by Taylor Jones, is a parking meter, reflecting the scandal of the Parking Violations Bureau that has rocked his administration.

Students created these fine political cartoons including a caricature, sometimes two caricatures.

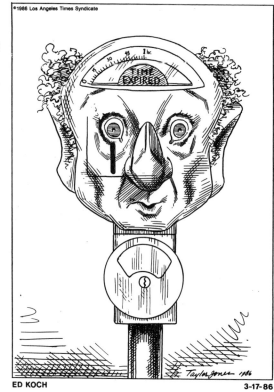

76

Now, determine the issues of the day as you did in the preceeding chapter. Decide how your personality can voice an opinion or be part of that issue, simply and directly with as much impact as the professionals.

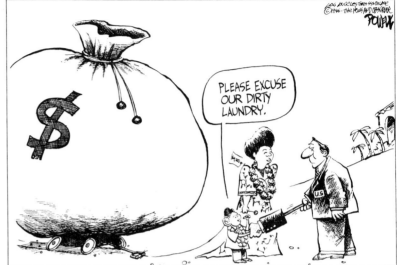

Dwane Powell. © 1986 The Raleigh News Observer. Reprinted with permission. Los Angeles Times Syndicate.

Rigby, New York Daily News

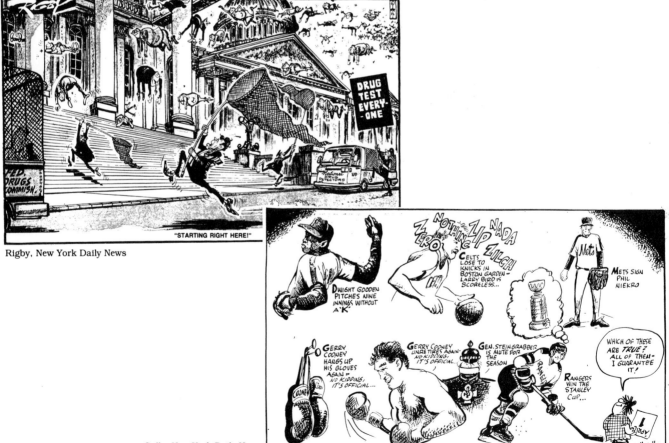

Gallo, New York Daily News

One day maybe several of you will appear in dailies all over the country. Maybe Presidents will rush to pick up the morning paper to see what you have decided to capture that day. Will it help his popularity? Hurt his chances for re-election? Help her push through legislation? Maybe these students' works would have made a difference.... maybe not.

# The Comic Strip

Comic strip characters in cartoons are one of the oldest forms of popular culture in today's world. They exert wide influence and are taken seriously around the globe. Millions of people in hundreds of countries eagerly await the appearance of certain comic strip characters in their daily and Sunday newspapers.

What is going to happen to Dick Tracy this week? Will Dondi's friend really abandon him for his new "family?"

**80**

# DONDI
## by Irwin Hasen

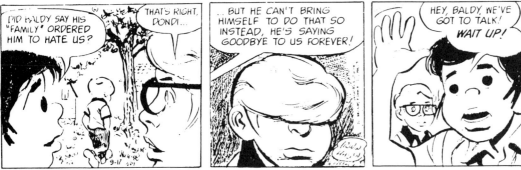

Irwin Hasen, Reprinted with permission: Tribune Media Services.

Looking for these answers has become a tradition, a genuine sociological and cultural phenomenon.

The immediate ancestors of today's comics are the works of 18th Century English "cartoonists." The main elements of today's comic strip appear in them:

> the story is told in sequence
> the characters are well sketched out
> there are even speech balloons!

The single frame cartoon and the continuing story with a permanent cast of characters soon follow. In 19th Century Europe the illustrative narrative takes hold and Charles Dickens becomes a scriptwriter for a famous illustrator, George Cruikshank. Imagine that!

On December 12, 1897 Rudolph Dirk's "Katzenjammer Kids" marked the birth of the modern comic strip. "LittleNemo," "Mutt and Jeff," "Krazy Kat," "Bringing Up Father," "The Gumps," "Gasoline Alley," "Barney Google," "Little Orphan Annie," soon follow.

Today the "Comics" is a flourishing art and literary form with political and social messages including issues such as nuclear proliferation, terrorism, and drug abuse. Famous people appear in comics — from Charlie Chaplin to the Pope, from Brezhnev and Reagan to George Foster of the New York Mets.

"Read all About It."
Better still, "Draw All About It."

Until now, every single drawing has been a finished statement. Now, we will enter the world of sequential art, where a panel begins a piece, followed by one or two in the middle and one at the end. The sequential development of an idea requires first of all an idea. That should represent no problem since all you have to do is refer to your journal.

Choose an entry that you have been eager to communicate—one that will cause the reader to smile, laugh, be horrified or enlightened. You may wish to read a few to your friends to find out which ones they enjoy. Use your character to voice the episode, real or fictitious. Translate this notation into a visual statement. Stare at these three panels below.

## 3 PANEL COMIC STRIP

INCLUDE: Your Character - Panel #1 = a MS (Medium Shot)·waist up
Panel #2 = a CU (Close Up) · Face
Panel #3 = a LS (Long Shot)· Entire figure in a setting

INCLUDE: Contrast - dark and light areas
: crosshatching and/or shading film ⇒ gray tones
: color - overlay/xerox

In a newspaper, an artist is designated a certain space. Each day or each week, this cartoonist must develop the idea in that given area and in that given format.

A good way to start is to draw three panels. Measure a strip in your newspaper and follow that overall size. The space around the panels is a *border*. The spaces between the panels are known as *gutters*. Leave room for your signature and date in panel #3.

Draw your character in panel #1 from the waist up. This is known as a medium shot in filmmaking terms. He/she should be doing something and/or talking to us.

In Panel #2, draw a closeup of your character reacting to or doing something expressive. (A closeup is a zoomed-in shot of a face or some detail such as a hand writing.)

In Panel #3, a long shot of the action will help us understand all that is going on and very often lends itself to humor. (A long shot is a zoomed-out shot of the figure from head to toe and sometimes shows the surroundings as well.)

First, lightly pencil your drawing. Make sure that
you have left room for the words in the speech
balloon or thought balloon. Make sure that the bal-
loons do not block out too much of the drawing.
Create the best composition you can.

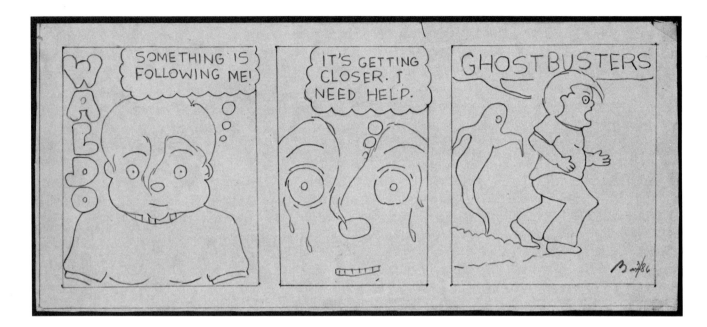

Next, photostat this pencil drawing of your comic
strip so you will always have this version intact. If
you make a mistake in the next step, inking, you
will not have ruined your original. Ink the photo-
stat, carefully darkening and adding variety to your
lines. Work in your shading film carefully and effec-
tively.

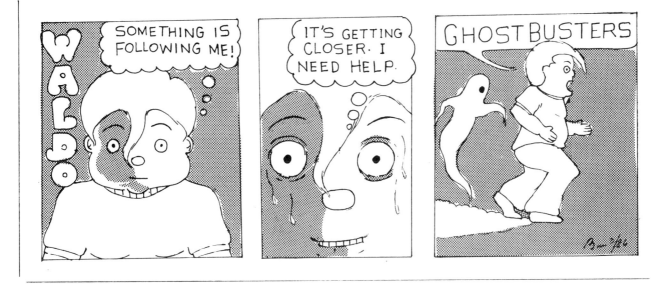

Photostat this version of the comic strip so that you will have a permanent copy. Ready yourself for the next step: the addition of color. Leave areas open, i.e., the hair and shirt so that simple, direct color can be easily applied.

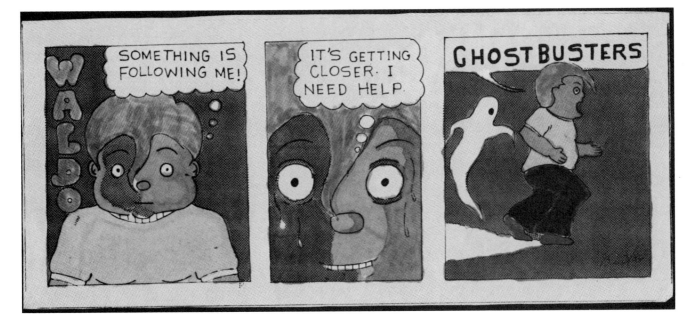

In this student's work the same sequence took place. Panel #1 is a M.S (medium shot). Panel #2 is a C.U. (closeup). Panel #3 is a L.S. (long shot).

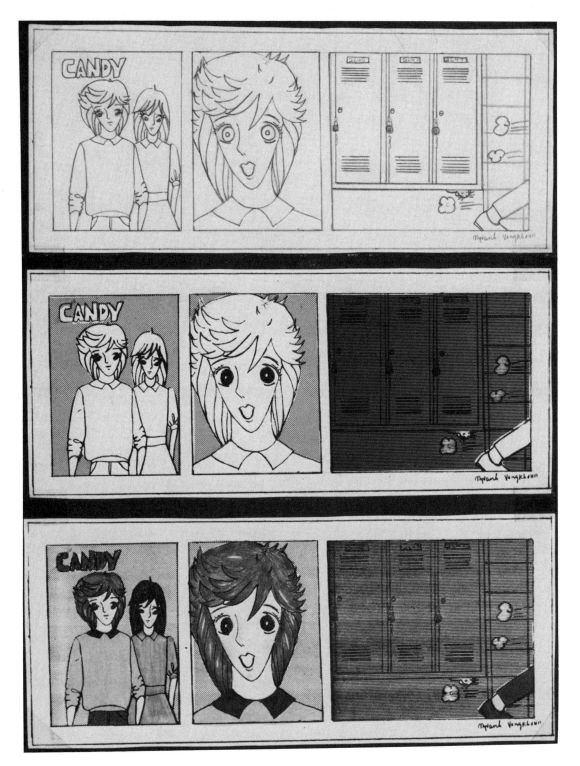

What is interesting here is that she felt no need
to add words. Body language and facial expression
say it all. Again, first the work is pencilled carefully
considering the composition in all three panels.
Then the work is photostatted, inked and shaded
with film. In this case, two types were applied. Light
dots in panels 1 and 2 and dark lines in panel 3
create greater contrast and movement. This version
was then photostatted again and colored simply
and directly.

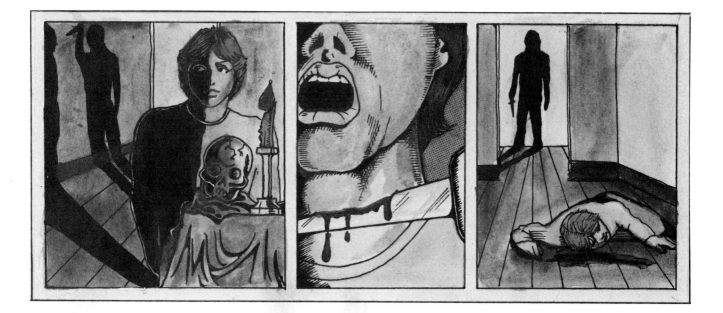

Although gruesome, this sequence is extremely
well done and very effective. Contrast, black areas,
dramatic lighting, silhouettes, excellent
crosshatching, some shading film and muted color
produce a powerful three frames. This student's
medium shot, closeup and a long shot sequence
depict a horrible episode with no words, not even a
scream as if in a frightening silent movie.

There are, of course, variations in the format and design of comic strips. There do not have to be three frames. This one has four and panel #1 has six panels worth of information. The absence of gutters compresses the information which works well with this student's message.

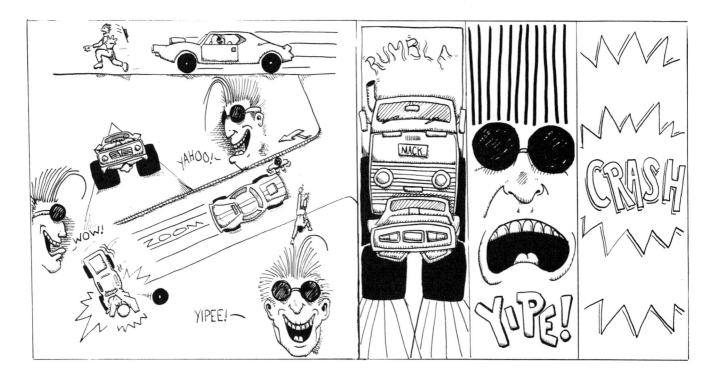

Nor does a strip have to start with a M.S., go to a C.U. and end with a L.S.

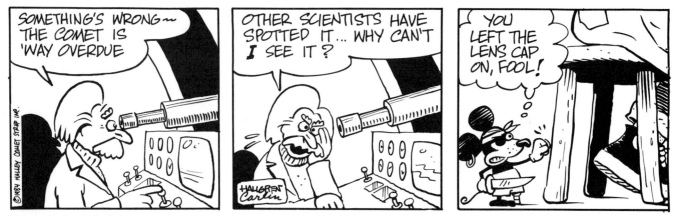

Hallgren/Carlin. Halley's Comics

In addition to varying the distance, i.e., closeup, medium shot, long shot, the cartoonist can also change the angle from which the character is viewed. Just picture yourself holding a camera while viewing these people in Gwenn Seuling's strips. Sometimes you are right in front, slightly to the right in back of the subject, above looking down in front of, above looking down in back of the person. Between varying distance and angles, there are infinite positions from which the subject may be viewed.

Gwenn Seuling

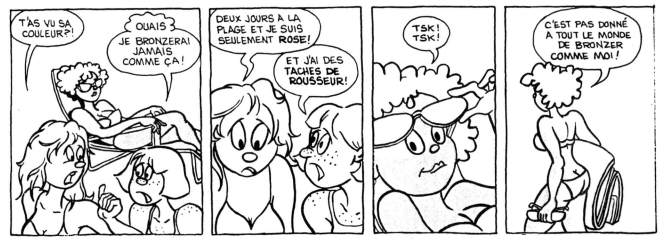

Gwenn Seuling

Irwin Hasen of "Dondi" fame emphasizes simplicity since the strip is reproduced very small and must compete with many strips on one page. He favors lettering the speech balloons first, in pencil, in a simple three panel construct.

His first panel suggests the locale—where the action is taking place. In film terms, this is known as an establishing shot. His middle panel suggests an interior shot (indoors) introducing the people with background etc. Hasen suggests an outside shot (exterior shot) for the third panel—a cliff hanger shot.

Although he does not follow his own formula, Irwin Hasen does develop this strip from an exterior shot to a cliff hanger keeping us anxious to find out what will happen in tomorrow's paper.

# DONDI®
## by Irwin Hasen

RELEASE WEEK OF SEPTEMBER 17, 1984

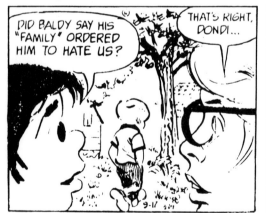 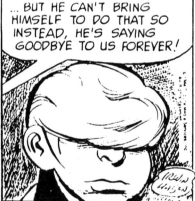 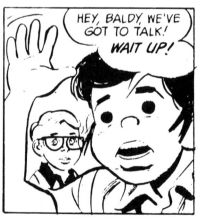

Irwin Hasen

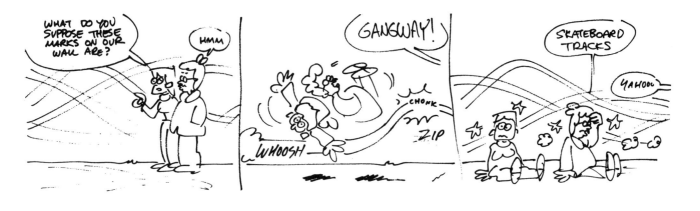

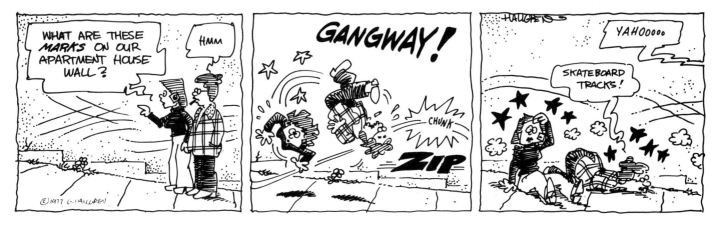

It is interesting to see how this rough sketch by Gary Hallgren is developed into the finished version. Note the changes in composition, copy and placement of information, not to mention borders, gutters, detail, contrast, crosshatching, stippling, etc.

Brumsic Brandon, Jr., creator of "Luther," uses an open panel, that is, no line running around the drawing in panel #1, and chooses to silhouette his characters here. In panels #2 and #3, the balloons are connected and readily move the reader to the conclusion. Shading film adds just the right touch.

**LUTHER**                                                                    **By Brumsic Brandon, Jr.**

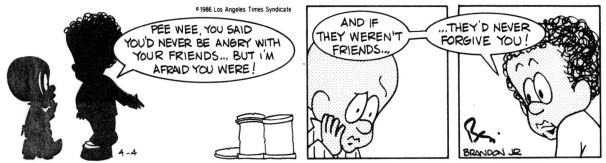

Brumsie Brandon Jr. © 1986 Los Angeles Times Syndicate. Reprinted with permission.

In the 1960's, Brandon was asked to create a black comic strip. He developed a cadre of characters and then named the strip. "The Inner City Kids." The editorial group rejected the name and finally settled on "Luther."

Brandon's approach is to set up a gag, hoping to lure the reader into perceiving racial connotations and then apply a non-racial punch line. In one strip, Pee Wee is being teased by his friends for wanting to be president. After leading the reader to believe that race is the cause, it turns out that his age and not his race was the major obstacle and the cause of the derision.

In the late 60s, the strip dealt with such issues as hunger, welfare, backlash and busing. "Luther" now invites readers to explore "basics" with him, as the inner city kids examine manners, friends, responsibility and lying. Cartoonists should "keep a finger on the pulse...keep up with the times...lead the way."

# The Comic Book Cover

Now that you are involved with sequential art and have created hundreds of comic strips, you should be just itching to develop an entire story, a tale you have always wanted to tell. A few places to look for these stories are: in your journal, your dreams, in short stories or poems *you* have written, the newspaper, or your imagination. This story should be original. The character who voices your thoughts can come from the one you developed in Chapter 2 or derived from the inanimate object into which you breathed life in Chapter 4. Or you might wish to develop a completely new character.

Character development in the "Comics" depends primarily on the writer's script. Usually the artist has only the sketchiest outline as to a description of the various participants in the story. Luckily, in this case you are both the author and artist and know exactly what is called for. Often blatant stereotypes are indicated: a thug, a sexy heroine, jut-jawed hero, slimy villain, etc. Here it becomes the artist's job to (as Gray Morrow would say) centrally cast á la Hollywood. The character should be delineated with some degree of perception and imagination. This is where the "fun" really begins,

translating these paper people into three dimensional interpretations of types that the reader will recognize and accept.

Gray Morrow has compiled a comprehensive file of character types from Hollywood character actors' old stills as well as photographs of friends and relatives. Whenever he needs a certain picture he consults his file and "nearly always finds the perfect one for the story...albeit with a little doctoring."

When called upon to create the prototypical "Hero," Gray Morrow suggests you use yourself as the model even if you don't resemble a Greek god. The magic of your pen and brush can easily remedy any deficiencies.

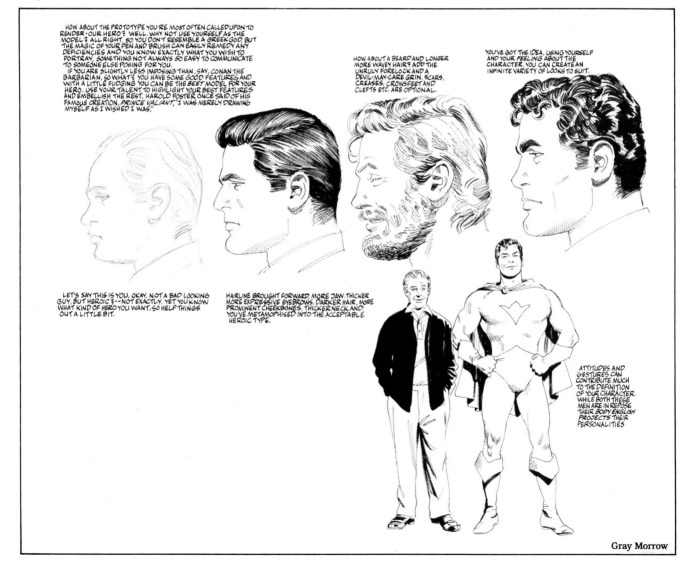

HOW ABOUT THE PROTOTYPE YOU'RE MOST OFTEN CALLED UPON TO RENDER - OUR HERO? WELL, WHY NOT USE YOURSELF AS THE MODEL? ALL RIGHT, SO YOU DON'T RESEMBLE A GREEK GOD, BUT THE MAGIC OF YOUR PEN AND BRUSH CAN EASILY REMEDY ANY DEFICIENCIES AND YOU KNOW EXACTLY WHAT YOU WISH TO PORTRAY, SOMETHING NOT ALWAYS SO EASY TO COMMUNICATE TO SOMEONE ELSE POSING FOR YOU.
IF YOU ARE SLIGHTLY LESS IMPOSING THAN, SAY, CONAN THE BARBARIAN, SO WHAT? YOU HAVE SOME GOOD FEATURES AND WITH A LITTLE FUDGING YOU CAN BE THE BEST MODEL FOR YOUR HERO. USE YOUR TALENT TO HIGHLIGHT YOUR BEST FEATURES AND EMBELLISH THE REST. HAROLD FOSTER ONCE SAID OF HIS FAMOUS CREATION, PRINCE VALIANT, "I WAS MERELY DRAWING MYSELF AS I WISHED I WAS."

HOW ABOUT A BEARD AND LONGER MORE WAVEY HAIR? ADD THE UNRULY FORELOCK AND A DEVIL-MAY-CARE GRIN, SCARS, CREASES, CROWSFEET AND CLEFTS ETC. ARE OPTIONAL.

YOU'VE GOT THE IDEA, USING YOURSELF AND YOUR FEELING ABOUT THE CHARACTER, YOU CAN CREATE AN INFINITE VARIETY OF LOOKS TO SUIT.

LET'S SAY THIS IS YOU, OKAY, NOT A BAD LOOKING GUY, BUT HEROIC? —NOT EXACTLY, YET YOU KNOW WHAT KIND OF HERO YOU WANT, SO HELP THINGS OUT A LITTLE BIT.

HAIRLINE BROUGHT FORWARD, MORE JAW. THICKER MORE EXPRESSIVE EYEBROWS, DARKER HAIR, MORE PROMINENT CHEEKBONES, THICKER NECK AND YOU'VE METAMOPHISED INTO THE ACCEPTABLE HEROIC TYPE.

ATTITUDES AND GESTURES CAN CONTRIBUTE MUCH TO THE DEFINITION OF YOUR CHARACTER. WHILE BOTH THESE MEN ARE IN REPOSE THEIR BODY ENGLISH PROJECTS THEIR PERSONALITIES

Gray Morrow

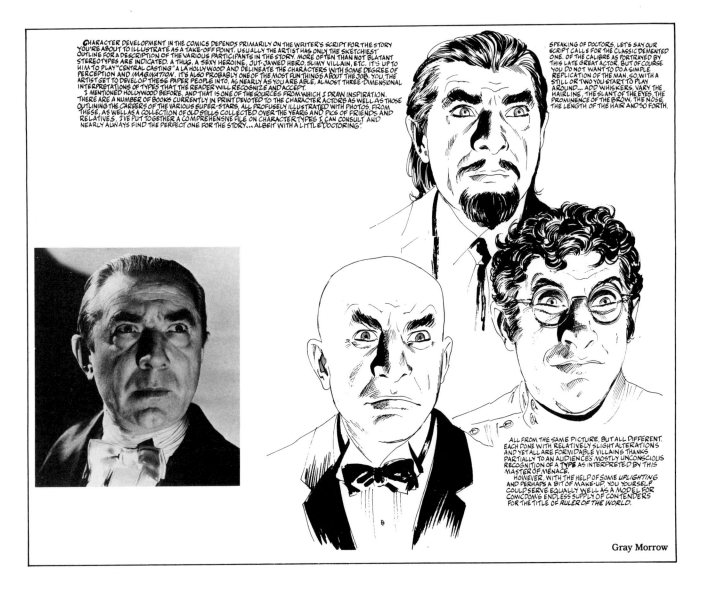

CHARACTER DEVELOPMENT IN THE COMICS DEPENDS PRIMARILY ON THE WRITER'S SCRIPT FOR THE STORY YOU'RE ABOUT TO ILLUSTRATE AS A TAKE-OFF POINT. USUALLY THE ARTIST HAS ONLY THE SKETCHIEST OUTLINE FOR A DESCRIPTION OF THE VARIOUS PARTICIPANTS IN THE STORY. MORE OFTEN THAN NOT BLATANT STEREOTYPES ARE INDICATED. A THUG, A SEXY HEROINE, JUT-JAWED HERO, SLIMY VILLAIN, ETC. IT'S UP TO HIM TO PLAY "CENTRAL CASTING" A LA HOLLYWOOD AND DELINEATE THE CHARACTERS WITH SOME DEGREE OF PERCEPTION AND *IMAGINATION*. IT'S ALSO PROBABLY ONE OF THE MOST FUN THINGS ABOUT THE JOB. YOU, THE ARTIST GET TO DEVELOP THESE PAPER PEOPLE INTO, AS NEARLY AS YOU ARE ABLE, ALMOST THREE-DIMENSIONAL INTERPRETATIONS OF TYPES THAT THE READER WILL RECOGNIZE AND ACCEPT.

I MENTIONED HOLLYWOOD BEFORE, AND THAT IS ONE OF THE SOURCES FROM WHICH I DRAW INSPIRATION. THERE ARE A NUMBER OF BOOKS CURRENTLY IN PRINT DEVOTED TO THE CHARACTER ACTORS AS WELL AS THOSE OUTLINING THE CAREERS OF THE VARIOUS SUPER-STARS, ALL PROFUSELY ILLUSTRATED WITH PHOTOS. FROM THESE, AS WELL AS A COLLECTION OF OLD STILLS COLLECTED OVER THE YEARS AND PICS OF FRIENDS AND RELATIVES, I'VE PUT TOGETHER A COMPREHENSIVE FILE ON CHARACTER TYPES I CAN CONSULT AND NEARLY ALWAYS FIND THE PERFECT ONE FOR THE STORY... ALBEIT WITH A LITTLE "DOCTORING".

SPEAKING OF DOCTORS, LET'S SAY OUR SCRIPT CALLS FOR THE CLASSIC DEMENTED ONE. OF THE CALIBRE AS PORTRAYED BY THIS LATE GREAT ACTOR. BUT OF COURSE YOU DO NOT WANT TO DO A SIMPLE REPLICATION OF THE MAN, SO, WITH A STILL OR TWO YOU START TO PLAY AROUND... ADD WHISKERS, VARY THE HAIRLINE, THE SLANT OF THE EYES, THE PROMINENCE OF THE BROW, THE NOSE, THE LENGTH OF THE HAIR AND SO FORTH.

ALL FROM THE SAME PICTURE, BUT ALL DIFFERENT. EACH DONE WITH RELATIVELY SLIGHT ALTERATIONS AND YET ALL ARE FORMIDABLE VILLAINS THANKS PARTIALLY TO AN AUDIENCE'S MOSTLY UNCONSCIOUS RECOGNITION OF A *TYPE* AS INTERPRETED BY THIS MASTER OF MENACE.

HOWEVER, WITH THE HELP OF SOME *UPLIGHTING* AND PERHAPS A BIT OF MAKE-UP, YOU YOURSELF COULD SERVE EQUALLY WELL AS A MODEL FOR COMICDOM'S ENDLESS SUPPLY OF CONTENDERS FOR THE TITLE OF *RULER OF THE WORLD*.

Gray Morrow

If you happen to be slightly less imposing than "Conan the Barbarian," don't let that stop you. Use your talents to enhance and highlight your best features and embellish the rest. Harold Foster once said of his famous creation Prince Valiant, "I was merely drawing myself as I wished I was." Isn't that afterall what a comic book hero is?

The Sexy Heroine or Jut-jawed Hero in most comic books or strips is created from a standard arrangements of features that contemporary society holds to be an ideal for female and male beauty. There is rarely any deviation from the array of lines and curves that says to the reader that "this is a

beautiful woman or handsome man." By doing a little more than relying on this stock image and changing only the hair color and styling, one can create a host of different heroic female and male characters.

Using photographs of movie stars or television stars or friends or relatives, begin to alter the features. You will be surprised and pleased with what you are able to achieve in the way of variety by changing the shape of the eyes, nose, mouth, and jawline.

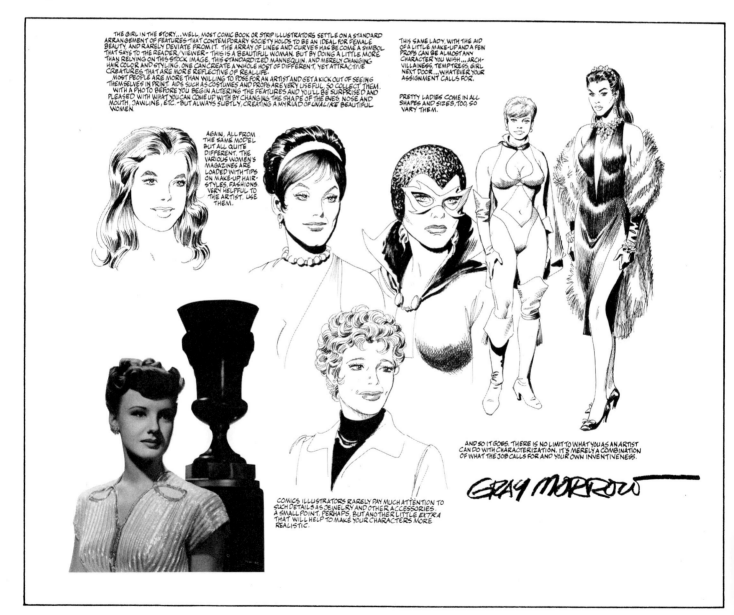

THE GIRL IN THE STORY... WELL, MOST COMIC BOOK OR STRIP ILLUSTRATORS SETTLE ON A STANDARD ARRANGEMENT OF FEATURES THAT CONTEMPORARY SOCIETY HOLDS TO BE AN IDEAL FOR FEMALE BEAUTY, AND RARELY DEVIATE FROM IT. THE ARRAY OF LINES AND CURVES HAS BECOME A SYMBOL THAT SAYS TO THE READER/VIEWER - THIS IS A BEAUTIFUL WOMAN. BUT BY DOING A LITTLE MORE THAN RELYING ON THIS STOCK IMAGE, THIS STANDARDIZED MANNEQUIN, AND MERELY CHANGING HAIR COLOR AND STYLING, ONE CAN CREATE A WHOLE HOST OF DIFFERENT, YET ATTRACTIVE CREATURES THAT ARE MORE REFLECTIVE OF REAL LIFE.

MOST PEOPLE ARE MORE THAN WILLING TO POSE FOR AN ARTIST AND GET A KICK OUT OF SEEING THEMSELVES IN PRINT. AIDS SUCH AS COSTUMES AND PROPS ARE VERY USEFUL, SO COLLECT THEM. WITH A PHOTO BEFORE YOU BEGIN ALTERING THE FEATURES AND YOU'LL BE SURPRISED AND PLEASED WITH WHAT YOU CAN COME UP WITH CHANGING THE SHAPE OF THE EYES, NOSE AND MOUTH, JAWLINE, ETC. - BUT ALWAYS SUBTLY, CREATING A MYRIAD OF *UNALIKE* BEAUTIFUL WOMEN.

THIS SAME LADY, WITH THE AID OF A LITTLE MAKE-UP AND A FEW PROPS CAN BE ALMOST ANY CHARACTER YOU WISH... ARCH-VILLAINESS, TEMPTRESS, GIRL NEXT DOOR... WHATEVER YOUR ASSIGNMENT CALLS FOR.

PRETTY LADIES COME IN ALL SHAPES AND SIZES, TOO, SO VARY THEM.

AGAIN, ALL FROM THE SAME MODEL BUT ALL QUITE DIFFERENT. THE VARIOUS WOMEN'S MAGAZINES ARE LOADED WITH TIPS ON MAKE-UP HAIR-STYLES, FASHIONS. VERY HELPFUL TO THE ARTIST. USE THEM.

AND SO IT GOES. THERE IS NO LIMIT TO WHAT YOU AS AN ARTIST CAN DO WITH CHARACTERIZATION. IT'S MERELY A COMBINATION OF WHAT THE JOB CALLS FOR AND YOUR OWN INVENTIVENESS.

GRAY MORROW

COMICS ILLUSTRATORS RARELY PAY MUCH ATTENTION TO SUCH DETAILS AS JEWELRY AND OTHER ACCESSORIES. A SMALL POINT, PERHAPS, BUT ANOTHER LITTLE *EXTRA* THAT WILL HELP TO MAKE YOUR CHARACTERS MORE REALISTIC.

There is no limit to what you as an artist can do with CHARACTERIZATION. It's a matter of combining your perception of what the script calls for and your own imagination and inventiveness.

Your story and character can come from an "origin," a tale about how some creature or hero was created. In this storyline by my eleven-year-old son, *Anura* was developed. His inception, travel to earth and the causes he champions are outlined as well as his powers and weaknesses. He was optimistically looking ahead as he delineated the plot possibilities for future issues.

ANURA has the natural power of hopping (up to 50 feet) plus the strange ability of staring into one's eyes and suddenly having them in a daze. Many say it's because he's so irresistably adorable, even the coldest of hearts can't help but fall in love with him. His costume (which he built himself) is solely for the purpose of keeping him strong and alive since Earth's atmosphere is chemically different from Terratt's and can weaken him. He cannot live a week without it. The unusual mechanical pieces extending from his ears allow him to communicate with animals.

PLOT POSSIBILITIES:
Defending national parks and forest areas
Getting people (students) to join his fight
Dealing with enemies who stand in his way
Fighting crime and corruption in cities
ANURA is an aware and adorable hero. He has a cause and the power to back it up.

Matt Sarnoff

97

In this story outline, I blocked out the origin of *Atomic Man* and his accompanying strengths which would aid him in his quest for peace and a safe and healthy environment.

Bob Sarnoff

Working near a vat of gloranium, a radioactive metallic element, Joe Jelinek's protective acrylic mask was torn off when an explosion slammed into his face, eyes, neck and right shoulder.

Mr. Jelinek, a nuclear process operator absorbed the largest known dose of radiation ever sustained by an atomic worker. At 10,000 times the acceptable level he was so hot as to set off Geiger counters 100 feet away.

Kept in isolation for a year, he was contacted only by specialists through glass walls and robotic machinery, washed repeatedly and injected with chemicals in order to flush the gloranium from his system. Walking with a limp, vision greatly impaired, his body remained highly radioactive.

Gathering strength via solar panels and megadoses of vitamins, Joe Jelinek plotted political and social retaliation during his reclusive waking hours and dreamed of alternative energy sources during his sleep.

Finally, powerful and physically and emotionally glowing, garbed in protective clothing, boots and mirrored mask, Joe became ATOMIC MAN.

Out to combat Big Business, The White House, Government, Conglomerates who care not for our environment, Atomic Man, a modern-day phantom of the opera, is able to gain entry to Top Secret files, is capable of absorbing microfiche information with a single glance, and escaping by emitting a ghostly ray leaving his pursuers entranced.

Able to appear on television at will, through his own microwave length, he has access to the eyes and ears and minds of the American public.

Stay tuned!

## Judge a Book by its Cover

How many times have you walked into a record store with just enough money to buy one record? When it came time to make your final decision, was it ever the album's cover that was the deciding factor? Millions of dollars are spent each year by advertisers to package their boxes of cereal, cans of juice, jars of coffee. Did you ever walk into your local newstand or comic book store with just enough money to buy one or two comics? Was it ever the cover drew you to choosing that one? Well, now that the covers have drawn you, we are going to draw them.

The cover is the most important page. It has be eye-catching, for it is, in essence, a full page advertisement. The cover must capture the attention of its audience, getting the message across quickly. Its impact should spark the reader to take the desired action—namely to buy the book! If it does not do this, it has failed its mission.

## Developing Your Cover

Choose your storyline. Read and examine the story and determine the focus or one of the most exciting events. Sketch out a few preliminary drawings that tell this event quickly, boldly, in a direct manner. Drop extraneous matter. Brief, clear, concise, bold, bright and clever are the key words. There should be as few elements as possible included in the design.

The following information appears on major comic book publications:

Group Name (The company that publishes the book)
Date (The month)
Price
Number
Approval Stamp by the Comics Code
Name of the Book
Logo
Computerized Price Code
Title of Story and/or Caption

The inclusion and organization of this information are vital in the design of your cover.

Your cover will measure approximately 8" x 11". In planning your cover your thumbnail sketches should be scaled down to the same proportion, i.e., 2" x 2¾" if you are working ¼ of the regular size. Try different arrangements incorporating all this pertinent information. Look at comic books and see how they deal with the placement of the price, date, number, etc.

Leave some "dead" areas within your powerful illustration. Dialogue balloons or captions should be offered on your cover. They can intrigue the reader. A caption is copy in which someone is talking to the reader, but which is not in a dialogue balloon.

Experiment with various styles of lettering. Your letters should be bold, open for inking and coloring. There are many different styles and types. Look in books on lettering as well as newspapers, magazines and comic books to find the one that best suits your story cover. *Expressive/Descriptive Lettering* is recommended. This "drawing" of a word is a clever and graphically powerful method of communication.

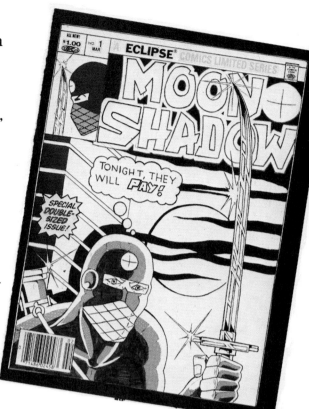

See how you can fit descriptive lettering into your cover design. Sometimes its use does not have to be explicit, that is, the style of lettering can help the communication as in "Ninja" or "Jade," or "Ms. Danger."

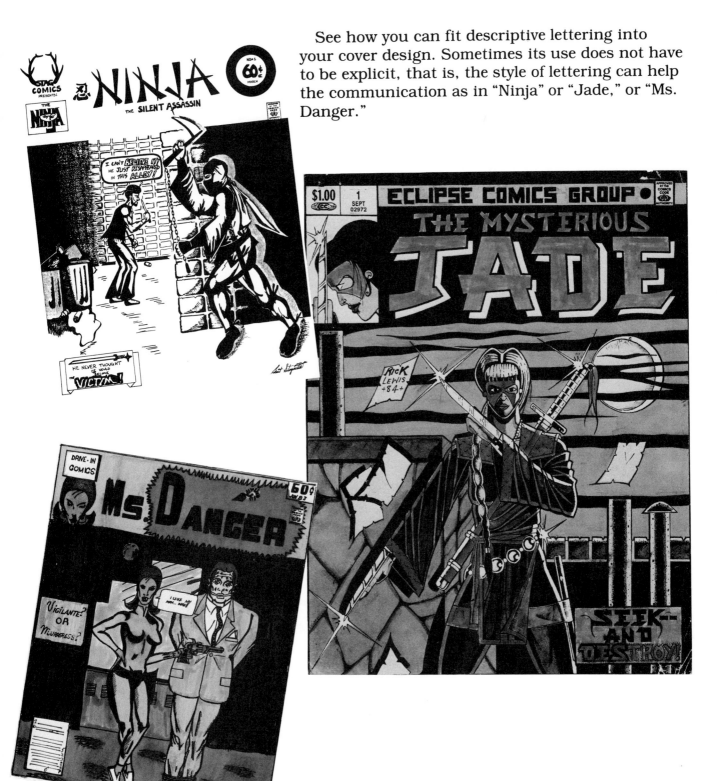

Experiment with different background shapes and lines of movement. But keep it simple: a complex arrangement of copy and intricate designs only serve to confuse. Remember our composition exercises.

From your preliminary thumbnail sketches, select the one that you feel has the best possibilities. A generous use of space, simplicity in illustration, strong contrast, clever, bold lettering are vital in the creation of an effective cover design. Remember, if the cover goes unnoticed, it isn't worth the paper upon which it's printed!

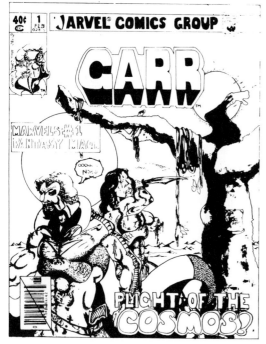

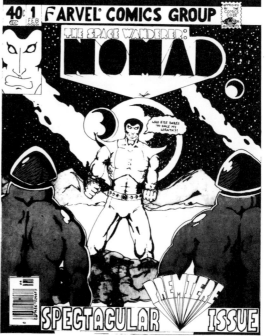

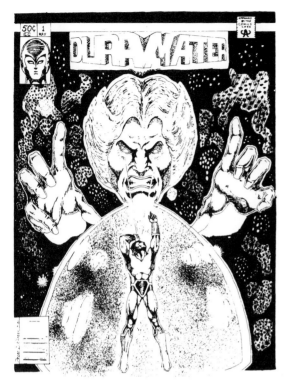

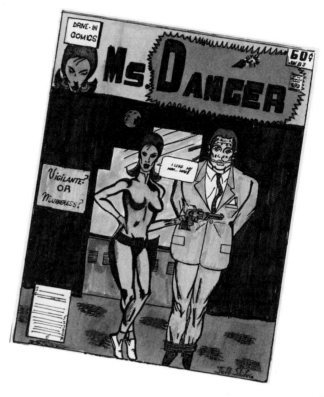

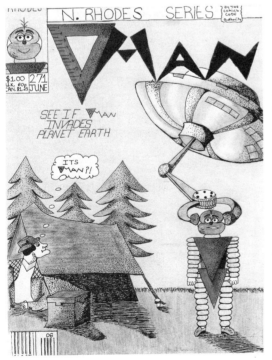

Explore the potential of color. Experiment with different combinations: light with dark, bright with dull. Look at your favorite comic book covers; determine why you like them. Examine the color schemes of posters, billboards, flyers, booklets, magazine ads, brochures and packages. Study how color is distributed throughout the design. A series of thumbnail sketches using various color schemes is most valuable in determining your final decision. Sometimes you have to be governed by color's symbolism, i.e. red for heat, heart, cherry. Realize that color can affect mood: Blue Monday, Purple with Rage, Green with Envy, etc. Color can also unify, as used in a background or strategically in spots. Color can create orderliness, continuity and contrast. It is a powerful and effective ingredient.

One more hint regarding the use of color: Use
black! Black creates strong contrast and produces
drama. White highlights this drama. Good luck!

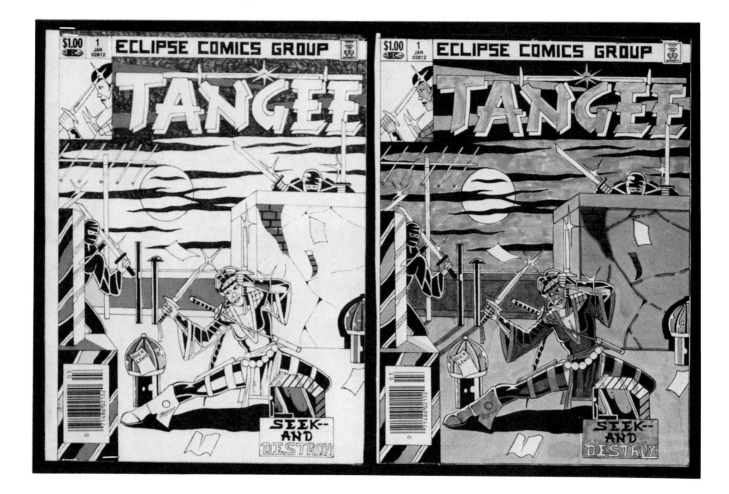

# The Splash Page

What is the second most important page in a comic book? After you are attracted to the bright, bold, exciting cover, what is the next step you take? Turn the page to find out more about the story, hopefully. That next page is called the splash page.

What is a splash page? It is really the first panel of a story with a large introductory illustration. The panel in this case is an entire page and contains the following information:

○ **Title**—the name of your story. In this student's illustration, *Vengeance* on the following page.

○ **Intriguing illustration**—drawing the reader further into your story.

○ **Credits**—Who is responsible for this magnificent comic book? Who created the story, pencilled the art, inked, colored, lettered, this masterpiece? Usually you will find several different names in the credits. Somebody wrote it, another person did the artwork, still another inked. In this case you will have done it all and you should be very proud.

○ **Indicia**—Technical, legal information necessary to protect, identify and make available to the readers the address of the publisher for subscriptions and other communication.

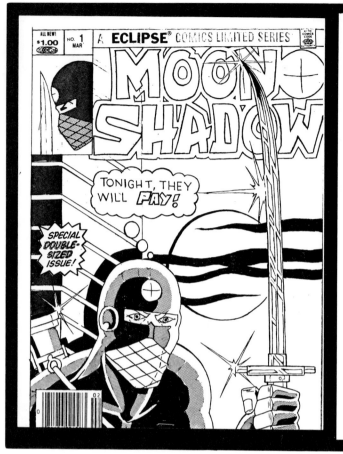

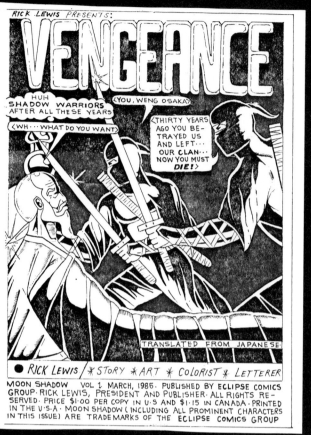

## A Splash Page May Also Include:

○ **Blurbs**—copy which relates to the title, i.e., "Caught in the midst of a nuclear explosion, a young man is affected supernaturally, gaining strange powers of spatial orientation."

○ **Thought balloons**—as in the illustrations shown here.

○ **Speech balloons**

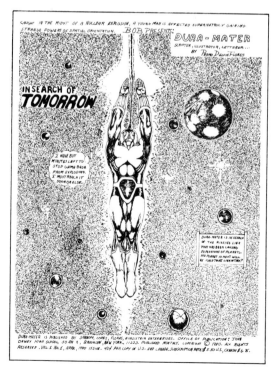

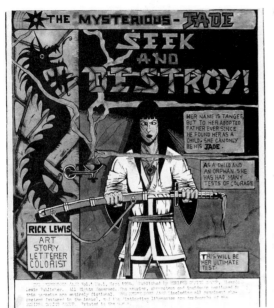

○ **Captions**—This is copy in which the narrator is talking to the reader (not within speech balloons).

(i.e.) Her name is Tangee.......Jade.

(i.e.) As a child........courage.

(i.e.) This will be her ultimate test.

## Developing Your Splash Page

Choose an illustration that will launch your story, your character into comic book history...soon to become a classic! You may wish to introduce your character, or jump right into the story and show your hero or heroine in action right off the bat. Create a few thumbnail sketches, again, being direct and uncluttered in your thinking and in your visual approach.

Consider the information necessary for a splash page, and develop your arrangement with this in mind. Will you use a blurb? Where will you place the caption if you choose to include one? Your splash page will be the same size as your cover, 8" x 11" approximately. The thumbnail sketches of your splash page should be in the same proportion, 2" x 2¾" if you are working ¼ of the regular size. Try different arrangements incorporating all this pertinent information. Look at your favorite comic books and see how they deal with credits, indicia, etc. in their splash page. Leave some "dead" areas for dialogue balloons, thought balloons, and captions.

Experiment with different lettering but be consistent with your cover. Use bold words, words that are inked heavier than others for emphasis. Use open letters, drawing them in outline with space inside for color to be added later. All this adds variety and excitement, making it easier and more fun to read.

From these preliminary sketches, select the one that you feel is best. A generous use of space, simple and direct illustration, strong contrast and

clever bold lettering will create the impact necessary for your public to want to read on.

Keep the same color combination that you decide upon for the cover. This will help unify the book and make it look professional. Again, use black and white for dramatic effect.

Wonderful composition, excellent, dramatic contrast, clever and skillful utilization of crosshatching and shading film are some of the ingredients in these two students' successful splash pages. The expressive/description lettering in the *Eradicator*, at the bottom of the page adds still another effective touch.

Don't you want to run out and buy these books? All of them? Don't you want to find out more about the adventures of *Moon Shadow, Dura·Meter, Jade, Nomad*, and the *Eradicator?*

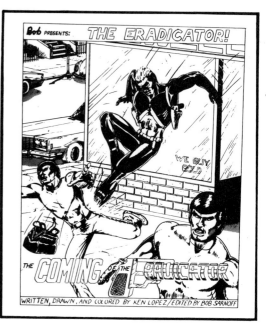

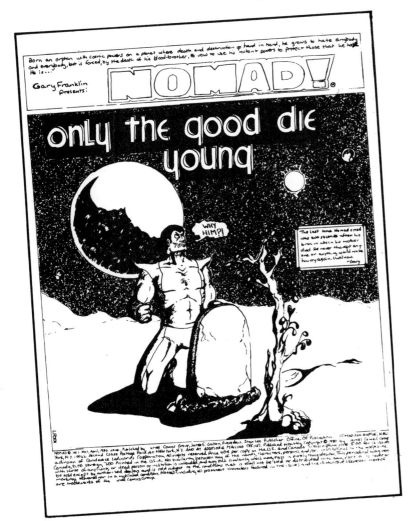

# Page by Page

As we have realized, the responsibilities of creating a comic book are divided among many people. Somebody writes the story, someone else designs the cover and a penciler draws the splash page. Still another artist inks it, and later another colors it.

You have before you your very own story, your very own cover and your very own splash page. So now it is your job to continue to translate your story, your words into pictures. Bring to visual life the scenes, the characters, the story. You have begun already with the cover and splash page. Just continue!

Faced with a big blank page upon which to draw, your job now is to communicate your plot to the "reader" in a visual way. Your main concern is drawing a series of still shots which develop your story clearly, concisely and creatively. A good way to test this is to show someone your page before adding the copy. You are in essence creating a silent movie, denoting passage of time and establishing the illusion of motion. Or, as in the illustration on the following page, creating a "foreign" (French) movie.

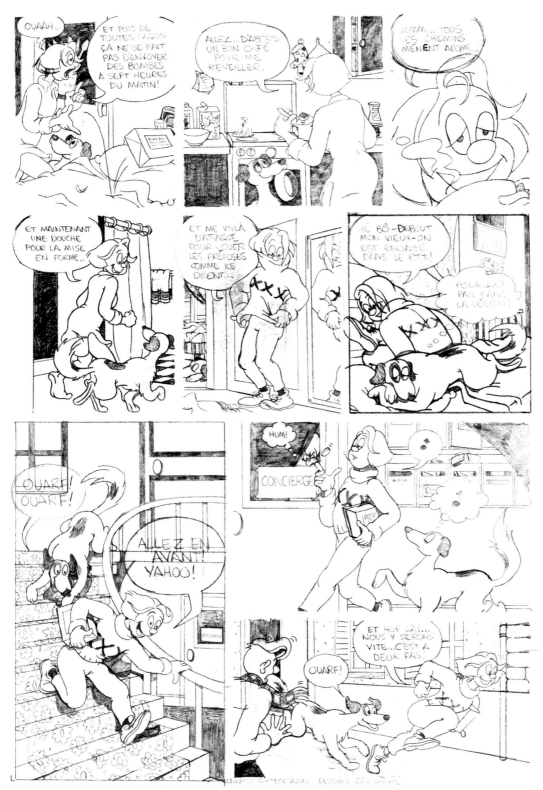

Gwenn Seuling

# The Comic Book Page

Read your storyline thoroughly until you can really determine what it is you wish to include on the first page. Composition has been discussed in terms of the positive and negative space and the arrangements of the elements in a given panel. Now the task becomes even greater as your space is the 8" x 11" blank page (same size as your cover and splash page) upon which you will be designing approximately eight individual panels. This arrangement involves still another composition problem, namely making the whole page look good, well composed, easy to follow, from panel to panel.

Irwin Hasen

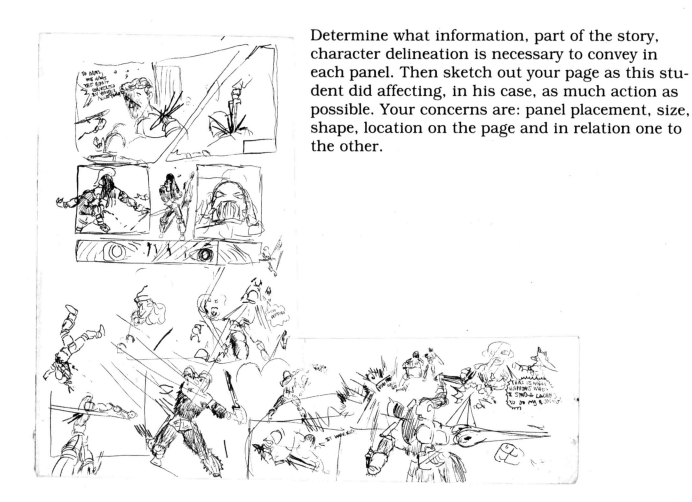

Determine what information, part of the story, character delineation is necessary to convey in each panel. Then sketch out your page as this student did affecting, in his case, as much action as possible. Your concerns are: panel placement, size, shape, location on the page and in relation one to the other.

Choose the correct shot:

○ **The Closeup (C.U.)**—generally speaking, the face or a detail, for example a wristwatch. This shot helps the reader see emotions and feelings, experience the moods, attitudes and reactions, and it of course portrays a studied description of the subject or object.
○ **The Medium Shot (M.S.)**—reveals more of the figure, usually from the waist up. Some action can thus be conveyed, for example, writing a letter at a desk, or working the controls of a space shuttle.
○ **The Long Shot (L.S.)**—a shot from head to toe showing the entire figure or figures, fighting, running, dancing, hugging, protesting, kissing.
○ **An Extreme Long Shot (X.L.S.)**—sometimes called an establishing shot, tells the reader

where the action is taking place, establishes the locale.

○ **An Extreme Close Up (X.C.U.)**—a zoomed in detail, for example, just the eyes, or the fuel gauge reading "Empty."

Shots can be varied in ways other than changing the distance between the viewer/reader and the subject. The filmmaker/artist can also draw from different **angles:**

○ **Straight on**—the normal view that most panels are drawn.
○ **Birds-eye View**—from above looking down at the subject. This is used as an establishing shot, depicting locale, or it can make one figure appear less significant, smaller, more vulnerable than another.
○ **Ants Eye View**—from below looking up. This shot can make a figure appear very significant, strong and imposing.

This illustration depicts some of the possibilities available to you. Looking at other illustrations in this chapter and perusing other comic book pages will open up still further avenues of expression:

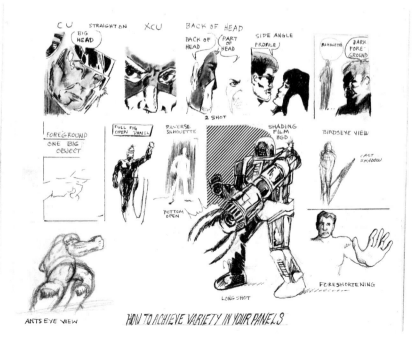

HOW TO ACHIEVE VARIETY IN YOUR PANELS

- ○ **Two Shot**—two people within the same panel.
- ○ **Silhouette**—outline of the figure blackened as light around it eliminates details.
- ○ **Oblique Angle**—tilted angle causing tension.
- ○ **Illusion of movement**—produced by a series of similar panels each changing slightly as the action in each seems to move.

In this student's page, the character's facial expression changes in the three panels as he becomes enraged.

In Gwenn Seulings' panels not only does the lighting change, but the shadow of the window pane creeps along, over and out as time passes.

Gwenn Seuling

Pencil your page: border, panels, gutters, characters, scenes, speech balloons, sound effects, suggest dark areas, gray areas, etc. Photostat your page. Ink the stat, using strong black areas, good crosshatching, shading film, etc. Keeping it simple and consistent, color your stat of the inked version.

This example of a panel's development from pencil to ink to color through the use of overlays reenforces what was said in prior chapters regarding inking and the addition of color.

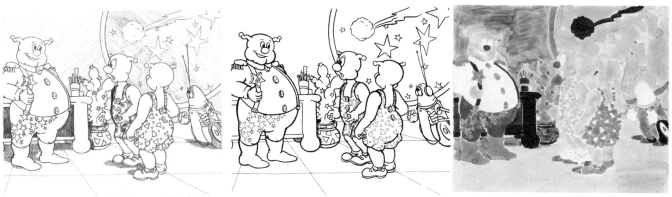

Gwenn Seuling

Look at your page. Is there a smooth, easy flow from panel to panel? Is your story being paced in an entertaining, easy-to-follow manner? Picture yourself to be a filmmaker/director. Is there good continuity? Do your actors/characters mouth your thoughts through your words and lettering? Bold letters and italics can emphasize certain points. Sound effects can be helpful too. Use all that is available so that the flow of action and dialogue on your page will be dynamic and exciting.

This student sets the tone in the very first panel—something is going to happen! Panel #2 sees his character (The Eradicator) flying out of the panel. Notice his left hand and the sound effect spilling over and into the adjoining panel. In panel #3, the overhead light creates a dramatic effect for this long shot. In panel #4 a dramatic two shot closeup of the battlers lets the reader see the pain and anxiety of the hero and the strength and evil of the villain.

The use of shading film for the first time in panel #5 creates variety in tone. Here, a M.L.S., (a medium long shot, not quite a long shot, not quite a medium shot) is used. An oblique angle, one that is tilted to create real drama and tension is depicted in panel #6 and in the last panel a birds-eye view, foreshortening and sound effects end the page with a terrific impact.

Excellent composition in all the panels promotes continuity and a flow of a quick paced scene. Black and white creates contrast and drama. Crosshatch-

ing textures, shadows, volumes develop a three-dimensional look. The inclusion of shading film sparingly in panels 5, 6, 7 creates still more variety and helps hold the page together.

In this exciting page by a student, friskit was used extensively to create an atmospheric effect and a variety of grays and textures. Friskit is a method of blocking off an area so as to protect it from an application of paint or ink.

In panel #3 the character was protected by a piece of stiff paper cut out in his shape and placed directly on top. Then a toothbrush dipped in India ink was sprayed around the figure. There are commercial products such as liquid friskit and friskit paper. Even rubber cement can be brushed over the protected area; later, when it is dry, simply rub the excess away. In using the toothbrush, make sure you have removed the excess India ink by rubbing your thumb over the bristles. Practice this procedure before applying ink to your panel. Where else on this page (Garr) do you see the student's use of friskit or shading film? Notice his use of open panels.

In this page, (Ninja) panel #1 shows a large figure in the foreground and a silhouette of the main character in the back, producing an extremely deep looking panel filled with drama and tension. Panel #3 is another example of friskit.

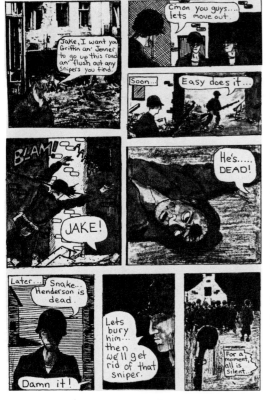

This student's page from "Jake and Snake" makes use of collage. In panel #1, the background is a photograph taken from a magazine. The character is superimposed (still another filmmaking term) by cutting him out and placing him upon the setting. When photostatted, this procedure creates a strong looking panel.

If you use establishing shots and vary your angles and distances, and if you establish continuity and excitement through strong composition in and among the panels, effect strong contrast, grays for variety, then you will have produced a page, a story, that flows easily, reads smoothly and communicates with your public no matter what language.

When put together with the proper thought, care, skill and love, the creation of a comic book page is a masterful accomplishment.

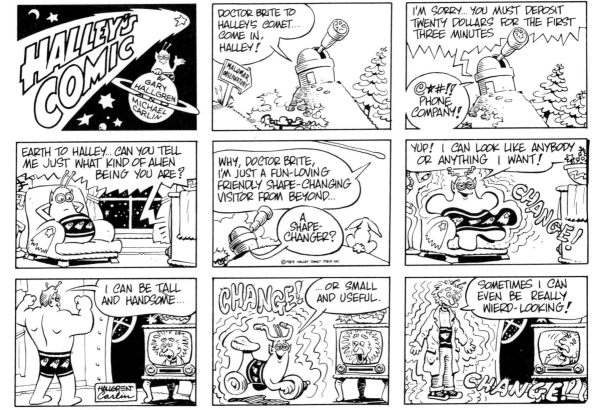

Gary Hallgren, Michael Hallgren

# None of the Above

## Other Ideas

In addition to the traditional expressions of "Cartooning" outlined in this book, you may wish to try some of the following:

## Monsters

When you walk along the beach, look down at some of the creatures, shells and natural fragments that have washed ashore. Some of these shapes and designs I am sure were the prototypes for space-ships and alien characters in popular science fiction movies.

The illustrations are of real life creatures.

With a little imagination and the application of your newly acquired skills and techniques, you can create your very own monster. Some students made collages, juxtaposing animal, insect, bird, etc...features upon human figures.

"REAL LIFE CREATURES"

## 3D Characters

Using a clay-like material that hardens in minutes when placed in a regular oven, called "Sculpy," you can translate any character into a three-dimensional version. This material is suggested because it hardens quickly and is easy to manipulate and paint. You could use papier mâché too.

When you have completed your three-dimensional character, you may want to shoot slides in various settings and produce a slide show including voices and music and perhaps sound effects.

## Foto Phunnies

Carefully select photographs from magazines and newspapers that you feel lend themselves to humor. Add your own comments in the form of speech and/or thought balloons. You may wish to create greeting cards from some of these or develop a book of foto phunnies.

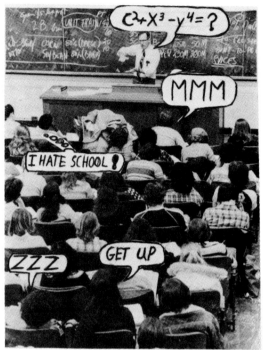

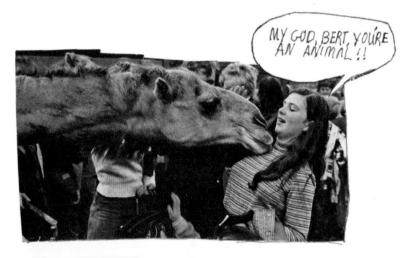

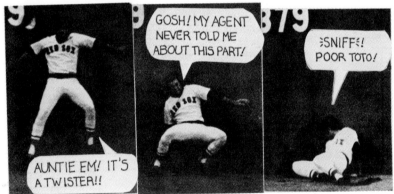

## A Morgue

While we are on the subject of photographs...Cut out pictures of automobiles, buffaloes, Chinese pagodas, dinosaurs, elephants, mountain scenes, ocean scenes, spaceships, trains, etc. File them in boxes alphabetically. Every time you read a newspaper, add a few pictures to your "morgue." Whenever you need to draw an airplane or a city skyline, it will there waiting for you at your fingertips.

## Entertaining Letters

If you look carefully at objects and details all around you, many of them have letters hidden in them. See if you can find at least one hidden example for each of the letters in the alphabet. Perhaps you can put together a clever little book for a young reader.

This book is meant to teach, motivate and inspire you. If along the way it opened your eyes and awakened your imagination to all the possibilities, then all the better, Have fun and Good Luck!

# Index